POSTCARD HISTORY SERIES

Hudson

On the front cover: Seen here is a view of Main Street in downtown Hudson taken from the town hall looking toward Wood Square about 1880. The street was not paved, nor were any automobiles using the streets yet, although electric trolley lines were active on the street. (Hudson Historical Society.)

On the back cover: This postcard shows the Hudson Town Hall with its bandstand (left), the Baptist church (center), and the Unitarian church (right). The town hall was built on land purchased for $10,000 at a total cost of $43,000 and dedicated in 1872. The bandstand is no longer present, nor is the Baptist church, and the town hall was recently renovated. (Hudson Historical Society.)

POSTCARD HISTORY SERIES

Hudson

Lewis Halprin and the Hudson Historical Society

ARCADIA
PUBLISHING

Copyright © 2008 by Lewis Halprin and the Hudson Historical Society
ISBN 978-0-7385-6284-1

Published by Arcadia Publishing
Charleston SC, Chicago IL, Portsmouth NH, San Francisco CA

Printed in the United States of America

Library of Congress Catalog Card Number: 2008904793

For all general information contact Arcadia Publishing at:
Telephone 843-853-2070
Fax 843-853-0044
E-mail sales@arcadiapublishing.com
For customer service and orders:
Toll-Free 1-888-313-2665

Visit us on the Internet at www.arcadiapublishing.com

CONTENTS

Acknowledgments 6

Introduction 7

1. Hudson's Historical Houses 11

2. Schools in Hudson's Past 17

3. Factories on the Assabet 27

4. Parades and Celebrations 35

5. Old Downtown 45

6. The Big View 63

7. Churches on High 71

8. Town Buildings and Memorials 87

9. Nature around Hudson 99

10. This and That 105

ACKNOWLEDGMENTS

Several years ago, when I was working on the book *Hudson* in Arcadia's Images of America series, Arcadia Publishing discouraged including postcards into that book, only good quality photographs. Although the archives of the Hudson Historical Society had thousands of old 8-by-10-inch glossy photographs donated by local newspapers, it also had hundreds of postcards of old Hudson that would have been good additions to the book. But now, thanks to improved printing technology, not only are postcards allowed in Arcadia books, but books featuring just postcards are encouraged. It did not take the members of the society long to submit a proposal for a Hudson postcard book, which was approved, and the book you are holding in your hands right now is the result.

But it takes more than a few hundred postcards to fill a book, since many of these postcards are duplicates or are very similar to each other. So the society put out a call to its members for others who might have collections of Hudson postcards and was very fortunate to get responses from four local postcard collectors who graciously provided us their Hudson postcard collection for the production of this volume. The initials at the end of each postcard caption throughout this book indicate from which collection that postcard belonged. They are as follows: Hudson Historical Society image archives (HHS), Paul Polewacyk (PP), Robert O'Hare Hudson postcard collection (RO), Vick Mackiewicz (VM), and William Bishop Jr. Hudson postcard collection (WB).

Informative captions are needed for each postcard, but most postcards come with only a few words to describe the picture on the card. Fortunately, Katherine Johnson, the historian for the Hudson Historical Society Museum, is an endless source of historical information about anything having to do with Hudson, especially old Hudson, and has been an irreplaceable asset in obtaining interesting and informative captions for each postcard. She also led the book-editing committee, consisting of Meg Fillmore, Jeannette Pauplis, and other society members who verified that the caption information was correct and presented properly.

The author recognizes that this book would not have been possible without the use of the borrowed Hudson postcard collections or the many hours of time spent by the members of the Hudson Historical Society in the creation of captions for these postcards. This book creation was indeed a group effort.

INTRODUCTION

In 1650, the area that would become Hudson was part of the American Indian plantation for the "Praying Indians," American Indians who converted to Christianity. The Praying Indians were evicted from their plantation during King Philip's War, and most did not return even after the war ended.

The first European settlement of the Hudson area occurred in 1699, when John Barnes settled here. He had been granted an acre of the Ockookangansett Indian Plantation the year before. There, on the north bank of the Assabet River, he built a gristmill. In 1701, he added a sawmill and bridged the river so that the road might continue on to Lancaster, which at that time reached almost to what is now Wood Square. Over the next century, Hudson grew slowly and the area was known as the "Mills."

The next 125 years brought slow, steady growth to this section of Marlborough, known as the Mills. Several small industries huddled close to the mill area, while stretching to the north and east were a number of large farms. In the early years, relations with the American Indians were very good, but as the settlers took more and more land from them, the American Indians tried to take back their land and drive out the settlers.

In June 1743, Samuel Witt, John Hapgood, and others living in the old American Indian plantation petitioned the Massachusetts General Court that their land be set off as a distinct parish or town, claiming that "it is vastly fatiguing to attend meeting in Marlborough, seven miles away." The Massachusetts General Court denied the petition.

Witt later served as a member of the Committees of Correspondence during the American Revolution. On April 19, 1775, when word came of the British march to Concord and Lexington, several men from this area joined their minutemen companies and marched to Cambridge to contain the British soldiers after their retreat.

In the early 1800s, in the suburb of Marlborough known as New City, a store was built called the Felton Store. Its owner prospered and became wealthy, and by 1828, the little community that grew around the store started to call itself Feltonville. Soon the community boasted a post office and hotel and was linked to Boston by stagecoach routes that went by way of Cox Street to Sudbury and then east to Boston.

In 1850, Feltonville received its first railroads. This allowed the development of larger factories, some of the first in the country to use steam power and sewing machines. New factories popped up everywhere. By 1860, there were 17 shoe or shoe-related industries. Immigrants from Ireland and French Canada were coming to join descendants of early settlers working at the 975 jobs available in the local plants.

The first Irishman of whom there is any record in Hudson was James Wilson, who arrived from Northborough in 1834. He bought one half acre of land on the north side of the country road in Feltonville. In 1845, Thomas McKeinis moved to Hudson, or Feltonville, as it was then called.

About 1850, Jerry O'Neil and Thomas Thornton came over to Feltonville from Shrewsbury. Patrick O'Neil came shortly after. He built a house on Cherry Street.

Between 1851 and 1866, other Irish people came and settled in many parts of town. They worked on the farms, in the factories, and later for the Boston and Maine Railroad. Some of the Irish settlers who came during this period were Tim Leary, Thomas Taylor, Pat Kerby, John Noon, Jim Noon, and Daniel and John Keating. One of the Keatings owned a house on High Street, which was then called Cork Hill because many of the Irish families lived there. Other families by the names of Gilroy, Feeney, Ryan, McCraith, Reddy, McCarthy, Regan, McNally, Murry, Murphy, Sullivan, and Kelly came to live in Hudson. Many of these people lived on Manning Street, which was then called Maple Street.

When the call to arms came in 1861, Feltonville citizens were ready, for they were a population of ardent abolitionists. Several local homes were stations in the Underground Railway, including the Goodale home on Chestnut Street and the Curley home (then called Rice Farm) on Brigham Street. Many young men went away to fight, and 25 died for the Union cause.

In 1865, with the war over, once again there was a move to make Feltonville a corporate town. A number of meetings were held in Union Hall and in the neighboring towns of Marlborough, Stow, Berlin, and Bolton. Petitions were sent to the Massachusetts General Court that a new town be incorporated from an area comprising the northern section of Marlborough with a bit from Stow. On March 19, 1866, the petitions were approved and Hudson was officially a town. It was named for Charles Hudson, a childhood resident who offered $500 toward a library. Two years later, Bolton sold two square miles of land to the new town for $10,000, making Hudson's area 11.81 square miles.

Over the next 20 years, Hudson grew as many industries settled in town, housed in modern factories; it became more diversified and attracted new residents. Within 20 years, two woolen mills, an elastic-webbing plant, a piano case factory, and a factory for waterproofing fabrics by rubber coating were built, as five new schools, a poor farm, and a wonderful new town hall were built, one that is still in use today. Banks were established, and five volunteer fire companies protected the mostly wooden structures of home and industry.

The population hovered around 5,500 residents, most of whom lived in small homes with little backyard garden plots. The town maintained five volunteer fire companies, one of which manned the Eureka Hand Pump, a record-setting pump that could shoot a 1.5-inch stream of water 229 feet.

Then disaster struck on July 4, 1894, when two boys playing with firecrackers at the rear of a factory on the banks of the millpond started a fire that burned down 40 buildings and five acres of central downtown Hudson. Nobody was hurt, but the cost of damages done was estimated at $400,000 (in 1894 dollars). However, the courageous and willing Hudson residents rebuilt the town within a year or so, providing a testament to the courage and will that has characterized the citizens since Hudson's inception.

By 1900, Hudson's population had reached about 7,500 residents, and the town had built its own power plant, so some homes were wired for electricity. Electric trolley lines were built that connected Hudson with the towns of Leominster, Concord, and Marlborough. The factories in town continued to grow, attracting immigrants from England, Germany, Portugal, Lithuania, Poland, Greece, Albania, and Italy. These immigrants usually lived in boardinghouses near their places of employment.

The year 1897 marks the beginning of Lithuanians in Hudson with the arrival of Anthony Markunas. Steadily they came along from places like Nashua, Boston, and Worcester, taking up residence in boardinghouses on Houghton, Walnut, and Warner Streets. Most of them were employed in the tanneries, rubber factories, and woolen mills. One of the first Lithuanians was Michael Rimkus. His grocery at the corner of Loring and Broad Streets was among the earliest

businesses and the longest extant (1908–1950). Another landmark was the Lithuanian Citizens' Club on School Street (1926–1960), which served social and recreational needs.

Almost without exception, Lithuanians sooner or later became homeowners, each having a garden and sometimes livestock. The traditional and beloved rue, as well as mint, chamomile, and other herbs were found alongside flowers and vegetables. Beekeeping was popular, especially with Karol Baranowski, who had an extensive apiary on Lois Street (now Mason Street), next to the unusual silver fox farm of Dominic Janciauskas.

By 1928, 19 languages were spoken by the workers of the Firestone-Apsley Rubber Company. Today the majority of Hudson residents are either of Irish or Portuguese descent, with smaller populations of those of Italian, French, English, Scottish, and Greek descent. About one-third of Hudson residents are Portuguese or are of Portuguese descent.

Since 1886, Hudson has graciously received an influx of Portuguese families, who have migrated principally from the Azores but also from Madeira and the mainland. These people are proud, loyal, and industrious, adjusting well to the life of this community.

Jose Tavares was the first to arrive, followed by brothers John and Manuel the next year. In 1888, came Joseph Braga, a youth of 18, and Antonio Chaves with sister Maria. The Garcia family of six came in 1889.

In the decade of the 1890s, four more names were added—Bairos, Correia, Luz, and Camara. Mr. and Mrs. Joseph Almada arrived in 1900 with her brother Manuel Silva.

By 1910, 11 more families were represented among the Portuguese in Hudson, known by names such as Rainha, Coito, Furtado, Pereira, Mello, Sousa, Costa, Pimentel, Resendes, Ribeiro, and Grillo. All of those reaching the town up to this time were from the islands of Santa Maria or Sao Miguel in the Azores.

In the next few years, more arrivals were noted from the Portuguese mainland, the only one still living today in Hudson being John Rio.

In 1916, during the expansion of the Apsley Rubber Company, greater numbers came to take advantage of employment opportunities. With continuing arrivals, by the 1920s close to 1,000 Portuguese were living here. They have not only entered the ranks of factory workers but have also started businesses of their own, adding to the financial well-being of the town.

The Portuguese community in Hudson maintains the Hudson Portuguese Club, which now has a newly rebuilt, state-of-the-art clubhouse. The Hudson Portuguese Club was established around 1910 and has outlived other ethnic clubs, such as the town's long-gone Buonovia Club. Recent immigrants to Hudson arrived mainly from Mexico, Central America, Brazil and other South American countries, Asia, and Europe.

Hudson's population remained about the same until after World War II, when developers started to buy out some farms that rimmed (and still do rim) the town. The new houses built on this land more than doubled Hudson's population. Recently high-tech companies have built plants and factories in Hudson, such as Digital Equipment Corporation (now owned by Intel). Although the population of Hudson is now about 20,000, the town still maintains the traditional town meeting form of government.

The cohesiveness of downtown Hudson took shape during the rebuilding that took place after the disastrous 1894 fire. All the new construction used similar materials and had similar shapes and heights. This unique appearance attracted a large number of photographers to take pictures of downtown Hudson and its surrounding neighborhood. The photographers of that time used large-format cameras with big glass plates as their negatives. Many of these high-detailed photographs were used to make postcards. These postcards were favored by the large immigrant population of Hudson in order to send home short messages to family members still located in Europe, showing them the places where they worked, the schools the children were attending, and the beauty of the town and neighborhood. Fortunately, many of these postcards were saved by local postcard collectors and are shared with you through this book.

It was during the Chicago Exposition of 1893 that 1¢ postcards printed only by the government first contained illustrations on one side of the card. Only the address was allowed on the other

side of the card, so any person who also wanted to send a short note with the postcard had to use the tiny margins around the picture to squeeze in the message. Private printers were allowed in 1898 to print their own postcards and to sell them, and the government created a 1¢ stamp to be used by buyers of nongovernment postcards in order to mail them. However, messages were still not allowed on the address side of the postcard. Several postcards in this book show attempts to write messages around the border of the postcard picture.

After many requests, the government allowed in 1901 for the address side of the postcard to be divided using the right side for the address and stamp, and using the left side for a personal message. By 1907, Germany was the primary printer of postcards since its lithographic skills were superior. With the development in 1915 by U.S. printers of being able to print postcards on linenlike paper, often with hand coloring, U.S.-printed postcards became predominant. Full-color postcards started to appear by 1930 and were used widely as souvenirs or as letters back home, especially when that home was Europe.

Some of the postcards in this book appear to be personal, and that is because they were. As an alternative to printing postcards, any photographer could also create his own postcard using special postcard-sized photograph paper on which would be a picture of a family member or a bunch of kids or a home and pet. These were all black-and-white only, were made to send to other family members, and probably were never on public sale.

Fortunately, postcard collecting was a favorite hobby for lots of families, some more energetically than others. The postcards in this book are primarily from six sources, namely the Hudson Historical Society photographic image archive, and from five local postcard collectors (see the acknowledgements) who generously shared their collection with us. This book organized these postcards by subject, many of them being similar but different views of the same subject. Subjects include Hudson's historic houses, its schools, its factories, its downtown, its churches, its town buildings and memorials, and wide views of the town from the surrounding hills.

So, sit down, put your feet up, and let the postcards in this book take you back to the way Hudson used to be, and in many cases, the way it still is.

One

Hudson's
Historical Houses

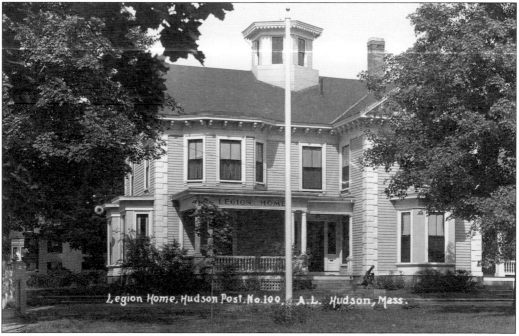

Legion Home, Hudson Post. No.100. A.L. Hudson, Mass.

The residence of the Honorable William H. Brigham, on Church Street in Hudson, later in 1933 became the site of the Legion Home of Hudson Post No. 100 of the American Legion. The home is now the Hudson Senior Center next to the Hudson Post Office. Plans are in place to remodel this home with additional rooms and more parking to accommodate the growing senior population of Hudson. (HHS.)

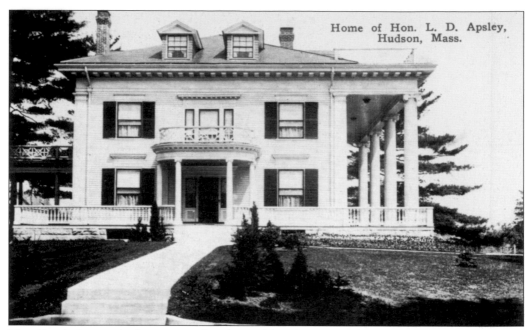

Hon. Lewis Dewart Apsley, owner of Apsley Rubber Company, had his residence on the corner of Pleasant Street and Lake Street. This home was built in 1905 with large elegant rooms, luxurious furnishings, and large fireplaces and mantels. Electricity was now in general use, and each room had ceiling fixtures but few electric outlets for reading lamps. The lower level had a billiards room and a bowling alley with two alleys. After dinner, the men would retire to this area to smoke and discuss business. Apsley was elected to the U.S. Congress and served from 1892 to 1896. A portico at the left of his home allows carriages and his town car to arrive under cover from rain. The tall columns at the right embellished a wide porch for sitting outside. (HHS.)

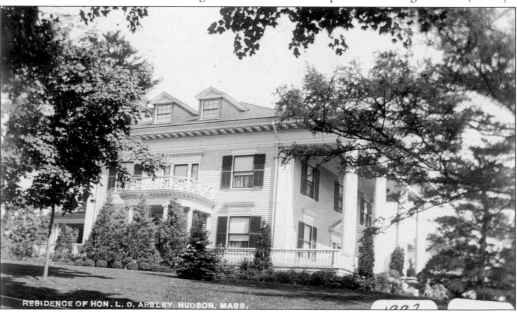

RESIDENCE OF HON. L. D. APSLEY, HUDSON, MASS.

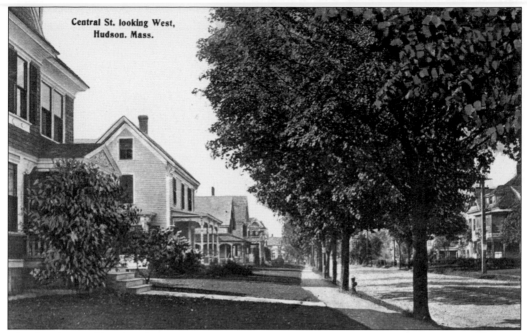

Central St. looking West,
Hudson. Mass.

This lovely neighborhood in Hudson is Central Street looking west from Irving Street. Central Street is also Massachusetts Route 62 within Hudson. This street is typical of many streets with lawns and shade trees, making a pleasant walk to the stores, library, and town parks. Hudson residents are proud of their community and show it. (WB.)

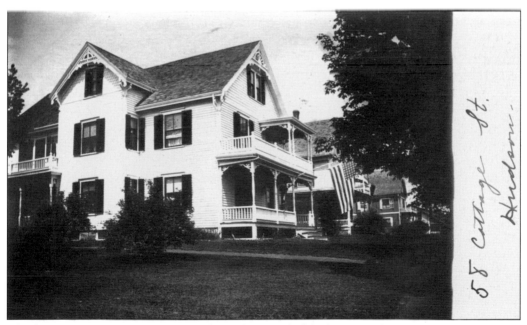

This house at 58 Cottage Street in Hudson was typical of the homes in the earlier days of the town. The homes and stores were built close together because walking was the mode of conveyance to church, school, and stores. The sidewalks were always busy with people and children. (HHS.)

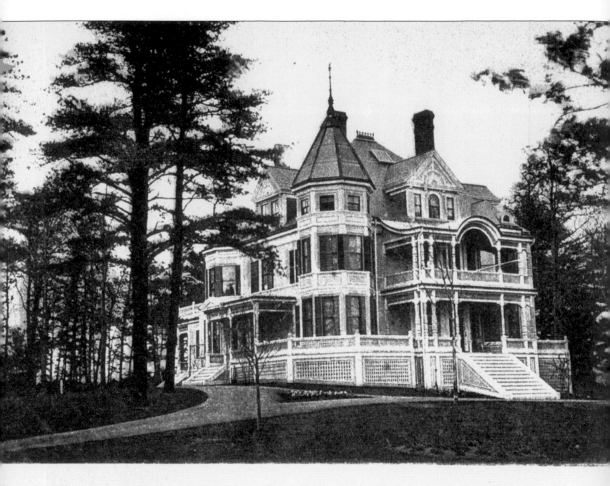

J. S. Bradley's Residence, Hudson, Mass.

This Victorian mansion, built before 1870, was the residence of Joseph S. Bradley and is located on Pond Street (now Lake Street) in Hudson. He owned Bradley Shoe Shop (1870), which later became Bradley and Sayward on Main Street. That business location was also the site of the Hudson Electric Light Station. He was born in 1823. At his death at age 85, he was a wealthy and honored citizen. He originally, as a lad, learned shoe making in Lorenzo Stratton's shop, the earliest shoemaker in Hudson. In 1850, he worked for Francis Brigham Company. He then was able to create his own business in 1870. Bradley served as the Hudson town treasurer for 20 years and was affiliated with many banks in Hudson, Marlboro, and Fitchburg. This big ornate home was later known as the Dawes Mansion and was heavily damaged by a fire in the 1960s, and is now the site of Peter's Grove apartments for elders. (HHS.)

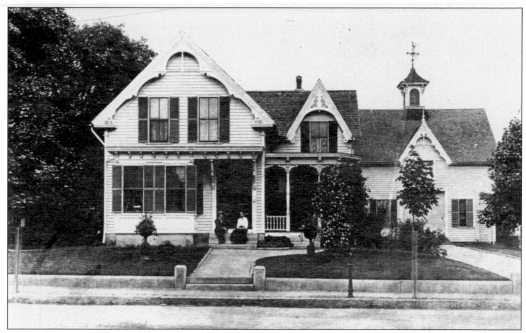

Frank Jones and his daughter Ethel lived in this house with its attached barn located at 2 Rice Street in Hudson. He was the stitching room foreman at the L. T. Jefts shoe factory for 30 years. He had begun to learn shoe making in 1850 when 20 years old. He married Harriet Maynard of Berlin and served with Company F, 13th Regiment in the Civil War. (HHS.)

Cox Square in Hudson is in front of the home of Willard and Susan Cox located at the corner of Central and Lincoln Streets in front of the Hudson Fire Station No. 1 on Route 62 west. The Hudson Fire Department decorates a triangular park here as a memorial to firefighters and gold star mothers. Susan "Aunt Suzie" Cox gave a generous fund to the town for elderly care. (HHS.)

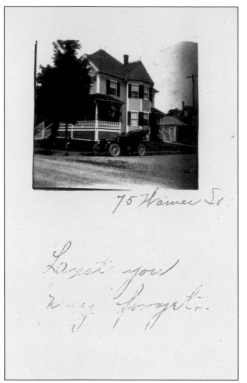

The home of Charles E. Wheeler, pictured in 1901, is at 75 Warner Street on the corner with Marion Street. Later Prof. Alfred Yesue and wife Mary lived here. He was a band director of the Catholic Youth Organization's Royal Jades and in bands in many towns starting in 1935. Shown parked in front of the residence is a beautiful touring car ready for a pleasant ride on a warm summer day. (HHS.)

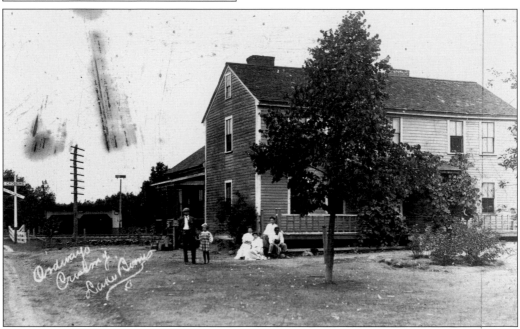

The Ordway family on Parmenter Road is sitting in the yard with the Ordway railroad station and its flag-stop tower in the background. James Ordway's home was built about 1750. He received some ears of Indian corn from New Hampshire. By planting only the best kernels year after year, he sold his excellent seed to the Burpee Seed Company, which developed from it the "Golden Bantam," the best of all corn varieties for years. (HHS.)

Two

SCHOOLS IN HUDSON'S PAST

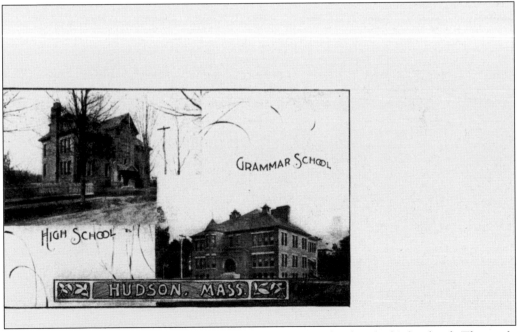

In 1900, Hudson had two large brick schools, a grammar school and a high school. The grade school was located in a neighborhood near enough so all could walk to school. They returned home for lunch and went back for the afternoon session with the same teacher and their 30 or more friends per class. (HHS.)

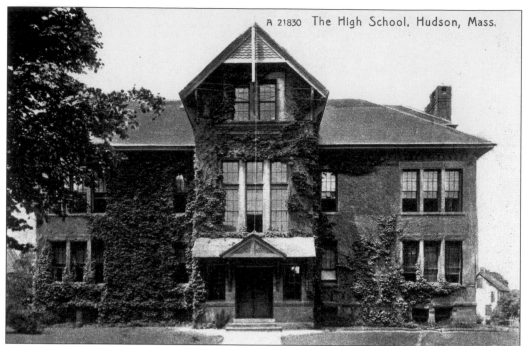

A 21830 The High School, Hudson, Mass.

The Hudson High School was built in 1882 on Felton Street and provided all the basics required for a high school diploma. There was great discussion to choose the site for this school with six being proposed. Finally a four-room school was built and two recitation rooms added in 1901 and then four more rooms in 1902. The courses offered gradually increased, adding bookkeeping. In 1892, 88 students were enrolled. In 1956, a new high school was built to replace this one. In 1969, the old high school building was reopened for sixth graders to use while a new school was being built to accommodate the increasing school enrollment. This old high school building was later remodeled to use for housing and is now known as the School House condominiums. (Above, HHS; below, WB.)

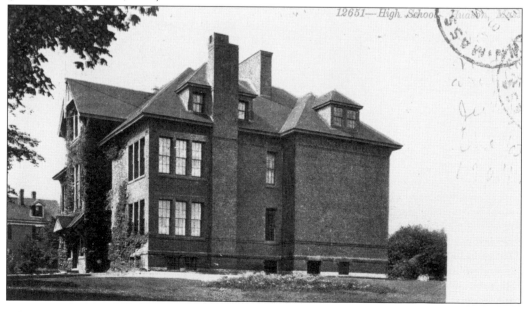

12651—High School, Hudson, Mass.

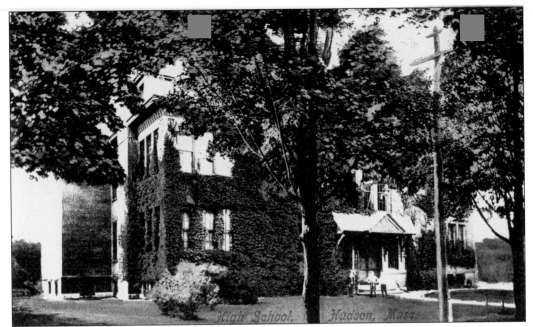

Before this high school was built, high school–level classes were held at the High Street School. A High School Association was founded in 1869 and continued with the new Felton Street High School that was built in 1883. The class of 1892 voted to plant ivy to cover the front of the building. These would enhance the building and keep it cooler. (VM.)

Copyrighted by J. Bergman, 1905. ILLUSTRATED POST CARD CO., N. Y.

Around 1900, the high school football team started to play games with neighboring towns, and these games became highly popular recreation that much of the town attended to cheer their school on to victory. This included the more energetic girls in the high school who dressed in their school colors, but not nearly as scantily as do today's cheerleaders. (PP.)

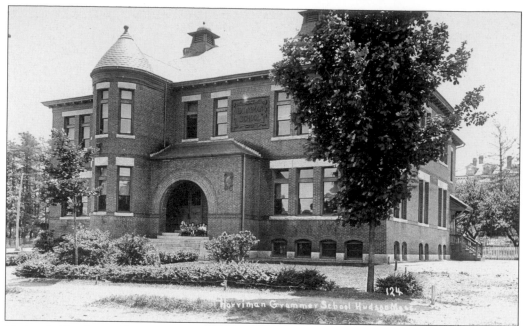

Hudson's Harriman Grammar School on Apsley Street housed grades one through eight and was named in 1905 for Dr. James Harriman, a prominent Hudson citizen, a local doctor for all families and member of the Hudson School Committee for 38 years. At a town meeting in 1892, the citizens voted $13,000 for a four-room brick building for a grammar school on Myrtle Avenue. Then it was amended to add $5,000 for a larger eight-room school to accommodate the increasing school enrollment. Myrtle Avenue was renamed after the Apsley Rubber Company was built on that street. This building is now the school administration building at the corner of Lake Street and Apsley Street. (Above, HHS; below, VM.)

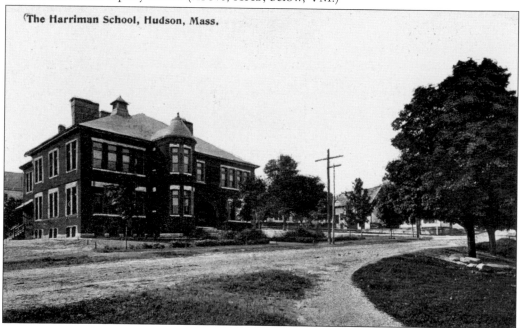

The Harriman School, Hudson, Mass.

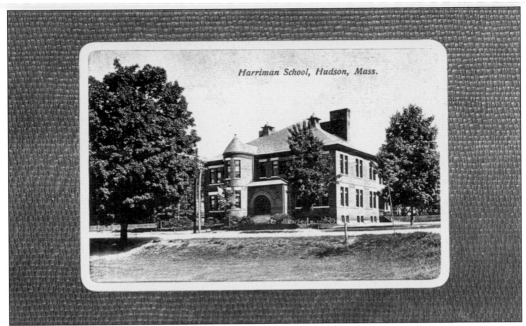

Harriman School, Hudson, Mass.

In 1891, this Myrtle Street School was built, and four more rooms were added in 1898. There were 107 pupils in 1892 and 195 pupils in 1895, and the number grew yearly. In 1907, a memorial tablet, measuring 8 feet by 12 feet, renamed the school in honor of Dr. James Harriman, and it became the Harriman Grammar School, now on Apsley Street. The tablet was the gift of his daughter, Blanche Reardon, and his wife Emma Harriman. Playground equipment and a lot were given by Abbie Beede, daughter of L. T. Jefts. In 1926, a Schoolboy Traffic Squad was formed, made up of all Boy Scouts, and used as crossing guards. They were given overshoes and sweaters, no pay. (Above, HHS; below, RO.)

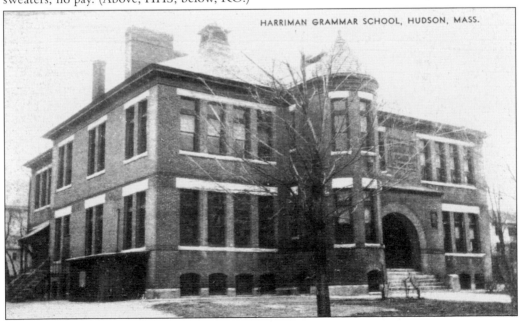

HARRIMAN GRAMMAR SCHOOL, HUDSON, MASS.

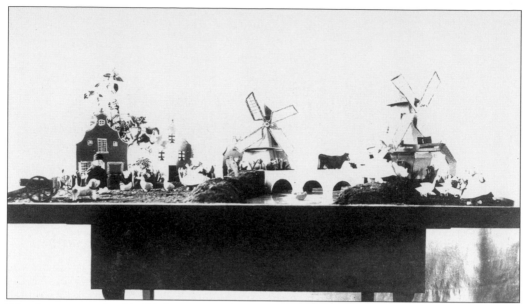

The elementary school in Hudson was studying about other countries and cultures and built little sandbox exhibits featuring each country. The sandbox above featured Holland, with windmills, a dike, a farm with animals and ducks, and people with wooden shoes. The sandbox below featured Japan with a blossoming cherry tree, a sampan, two rickshaws, a pagoda, and Japanese figures with parasols. The students had fun planning how to interpret and imagine what life in another country might be like. Each could bring an item from home like a doll or a duck to add. The crepe-paper cherry blossoms might have been made by girls in an art class. (HHS.)

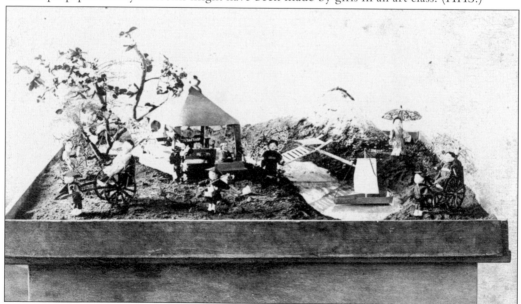

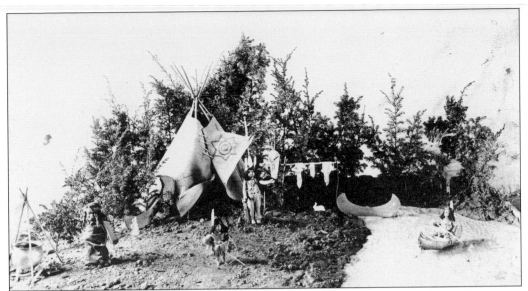

In the series of sandboxes that the Hudson elementary school built while studying about other countries and cultures was one that featured American Indians (above). That sandbox scene shows an American Indian family enjoying a comfortable home that included a wigwam, cooking area, skins drying from the hunt, and fishing and a canoe on the Assabet River. An American Indian scene would be especially fun with green branches from their yards, a handmade birch bark canoe, and a doll with a feathered headdress. The sandbox shown below featured Switzerland by showing a village among the mountains, stones on the roof to protect it from the winds, and Heidi and her mountain goats. (HHS.)

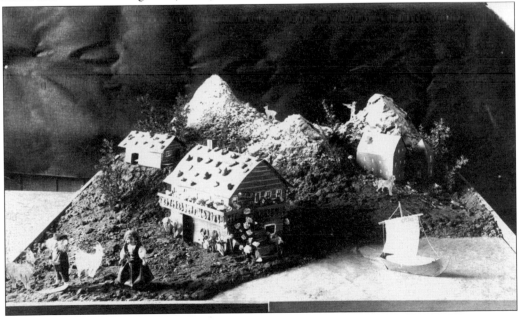

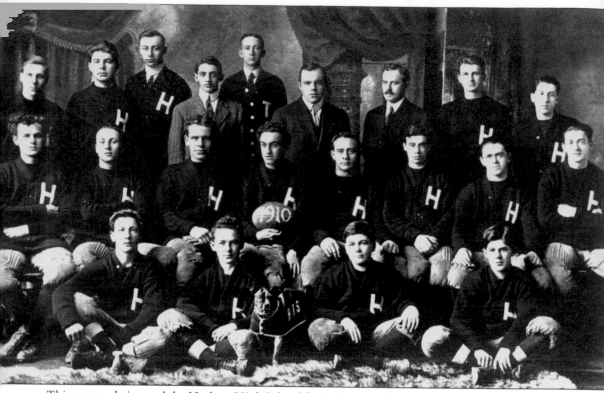

This postcard pictured the Hudson High School football team of 1910 that consisted of 22 players and a bulldog mascot. Their outfits are quite simple compared to today with padded pants, high shoes, and much less body padding. In those days, football was the most popular sport in this part of the state. Hudson had the first lighted football field in this area and allowed the stadium to be used for night games. The stadium was developed where the trotting park used to be. Seen here are, from left to right, (first row) Eddie Kearney, Neil McDevitt, a bulldog (name unknown), Charlie Molloy, and Lucius Garcia; (second row) Chester Lamson, Steve Morgan, Bill Brigham, Leo Lapointe, Chuck Eddy, ? White, Bill Clancy, and George Richardson; (third row) Irving Whitelaw, John Hurlburt, Foster Best, Franklin Lewis, James Parkinson, Larry Duffy, C. A. Williams, Emory Poor, and Elmer Matthews. (HHS.)

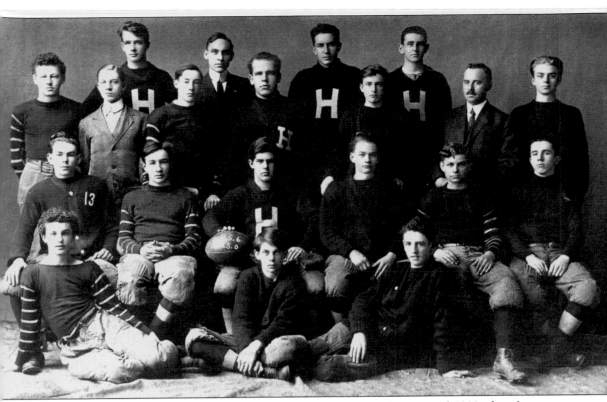

This picture of the Hudson High School football team was taken around 1911 after the team beat its archrival Marlborough High School 6-0. The Hudson High School football team played its neighbor Marlborough every Thanksgiving Day, regardless of the weather, and would alternate which school's field would be used. The rivalry has been going on for over 100 years and still takes place every Thanksgiving with full stands every year full of students, their parents, and friends, many of which were Hudson High School students attending these games in years past. Seen here are, from left to right, (first row, on the floor) Talbert Norman, Leslie Brigham, and Francis Schofield; (second row, sitting) Ralph Ruggles, W. Stammers, Lucius Groves, William Sawyer, Edward Wendall, and William Duffy; (third row, standing) Frank Lamson, William Wadbrook (manager), George Higgins, William Brigham, Chester Griffin, Charles Williams, and Merlin Cochrane; (fourth row, back) Earle Green, W. E. Lane (coach), Roman Mirrigan, and William Schofield. (HHS.)

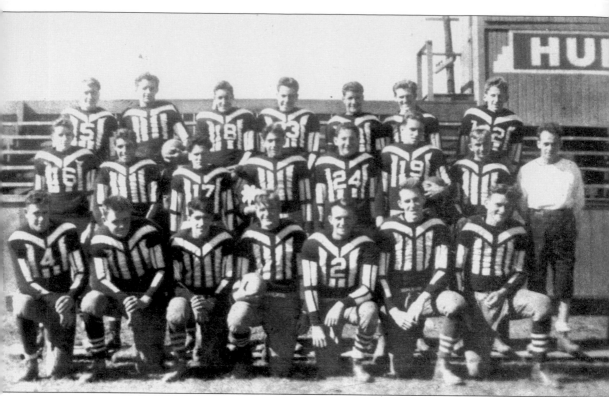

In 1939, the Hudson High School football team played 10 games, with 7 of them at their home field against teams from the towns of Ashland, Methuen, Athol, South Worcester, Central Worcester, Natick, and the most important game of the season, Marlboro, which was always played around Thanksgiving. The three away games were with Maynard, Clinton, and Milford. Of the home games, four played were played at night since their football field had lights installed. The players on the 1939 Hudson football team were, from left to right, (first row) David Quinn, Robert Beals, Joseph Barriera, William Orlanski, George Ober, Joseph Visnoski, and James Walsh; (second row) Kenneth Holland, Edward Figueira, Henry Coite, Joseph Rego, Richard Videto, Robert Ryan, Charles Baronowski, coach Robert MacCarthy; (third row) Robert Clattenburg, Charles Jacobs, Frank Sousa, Joseph Texiera, Fernando Justo, Harvey Collins, and David Lamson. (PP.)

Three

FACTORIES ON THE ASSABET

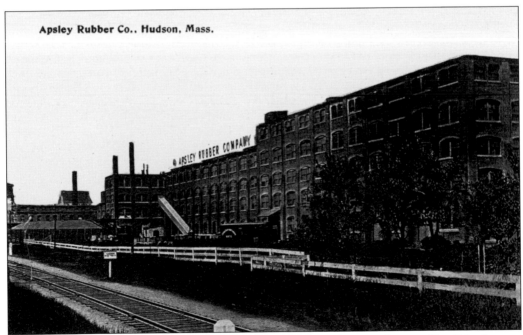

Apsley Rubber Co., Hudson, Mass.

This is the image of the Apsley Rubber Company in Hudson, showing the rear side of the factory. The Boston and Maine Railroad tracks are shown in the foreground. The first building of this complex was built in 1895, followed by a second building in 1905. By the 1980s, the building was subdivided into many companies. (HHS.)

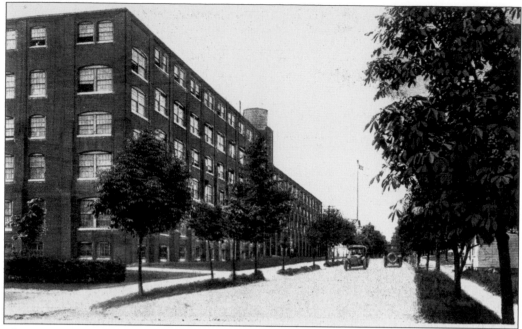

This image shows the Apsley Rubber Company campus of factories on Apsley Street in Hudson, looking west. The plant manufactured rubbers, overshoes, rubber boots, raincoats, and rubberized cloth called "gossamer." In 1892, Lewis Apsley obtained 16 acres on which to build many sections of his factory. He employed up to 2,000 workers at times, more than half of all those employed in the town. In 1921, the business was sold to Firestone Tire and Rubber Company. The tall 150-foot smokestack still spells "Firestone" on its side. In the 1940s, Victory Plastics made plastic footwear and plastic scabbards, 18 million of them, to protect knives and machetes of all sizes during World War II. Victory Plastics Company was the first in the United States, and the youngest, to receive the Army and Navy Award, one of only five awarded. (Above, VM; below, HHS.)

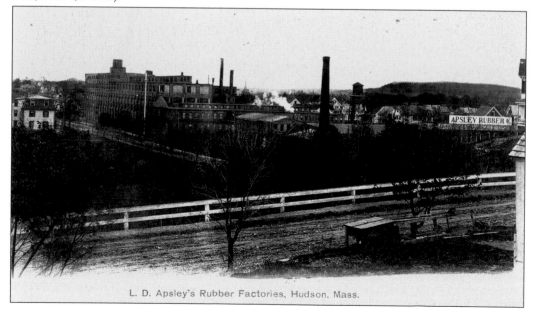

L. D. Apsley's Rubber Factories, Hudson, Mass.

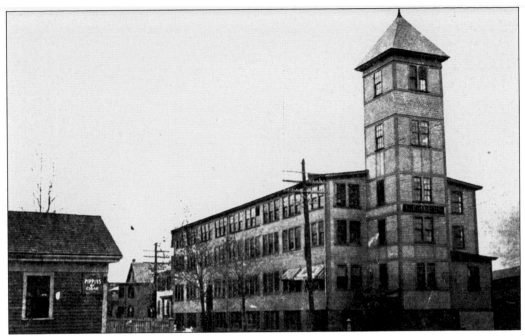

The L. T. Jefts Factory, built in 1859, was on the corner of Broad and South Streets in Hudson. A new factory, 100 feet long, was built in 1880 to make women's shoes, employing 150 workers. In 1888, a fourth floor was added. In 1937, it became the Braga Shoe Company factory, and in 1972, it became LaRosee and Company. (HHS.)

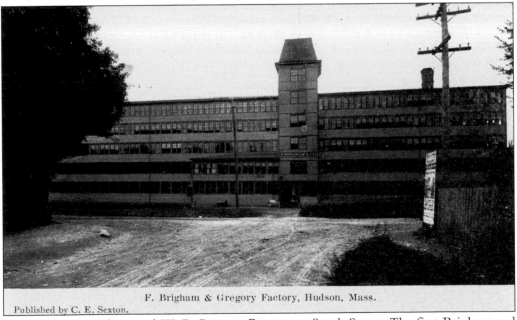

F. Brigham & Gregory Factory, Hudson, Mass.
Published by C. E. Sexton.

This is the F. Brigham and W. F. Gregory Factory on South Street. The first Brigham and Company Shoe Factory was on Main Street and used a horse walking in a circle to turn gears that drove the machinery. In 1857, Francis D. Brigham built four Brigham Shoe Company factories using the Assabet River for waterpower. Later this factory became the Ascutney Shoe Company and was destroyed by fire in 1971. (WB.)

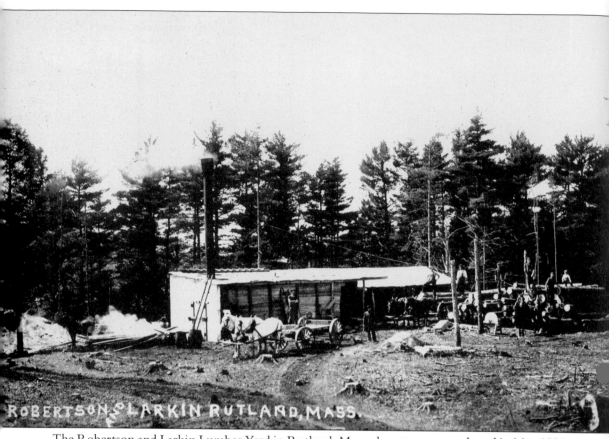

The Robertson and Larkin Lumber Yard in Rutland, Massachusetts, was purchased in May 1884 from the Tower brothers and expected to cut 500,000 feet of lumber by the spring of 1885. A new building was built in November 1889 to process more wood. This was near the Fitchburg Railroad so the wood could be delivered easily to Hudson by rail to the Larkin Lumber Company. In Hudson, the company was located just off Main Street back to Bruce's Pond with a canal

from the pond leading to the Assabet River, going under Main Street. In 1889, Robertson and Larkin purchased the old mill erected by Horatio Bruce when he built the millpond. In 1929, electric motor power was introduced, having previously used waterpower from the falls on the canal. (HHS.)

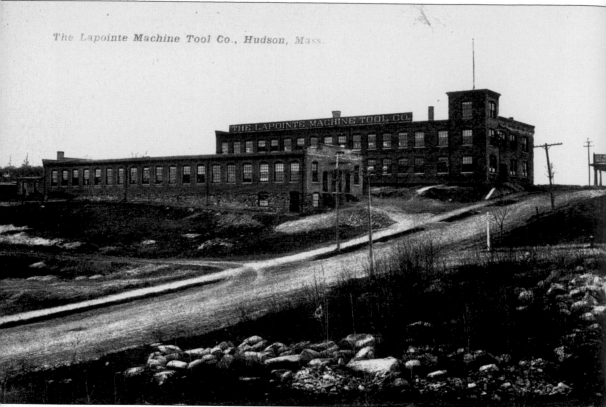

The Lapointe Machine Tool Co., Hudson, Mass.

The Lapointe Machine Tool Company, founded in 1898, moved to Hudson in 1903 and developed into the world's oldest and largest producer of broaching machines widely used in manufacturing and machine tooling by the aircraft and automotive companies, as well as the automatic rifle and firearms industry. This factory on Tower Street was built in 1917. At the time, Tower Street was a dead-end street, but it is now a thruway. Some major customers of Lapointe Machine Tool Company included the United Shoe Machinery Company and the Ford and Packard Motor Companies. The Lapointe Machine Tool Company was one of Hudson's largest industries, and its technological advancements brought numerous awards during World War II for its outstanding contributions in accelerating gun production and saving many American lives. The plant closed in 1970. The New England Tape Company building is shown in the foreground. (HHS.)

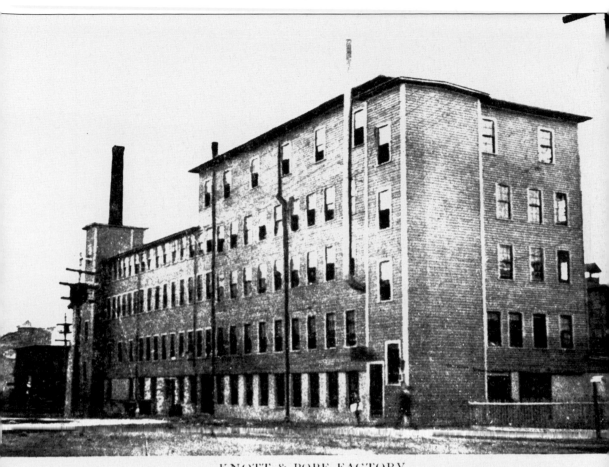

KNOTT & POPE FACTORY

The Knott and Pope Factory on Houghton Street, which later became the Webster Shoe Factory Store, was where one bought children's sneakers directly from the factory. It was torn down in the late 1990s. In 1903, James E. Knott, for 23 years a salesman and bookkeeper for Bradley and Sayward, and Frank C. Pope, a leather merchant in Boston, joined to form Knott and Pope Company. Knott was local, and Pope had the capital. In 1906, they moved into this building, where they made 4,000 pairs of shoes per day. They closed on August 1, 1918. This factory had been part of George Houghton Company, which was Hudson's largest shoe company. The part showing had been separated from the main buildings on Main Street, which was fortunate, as the largest section on Main Street was all destroyed by a fire on January 7, 1904. (HHS.)

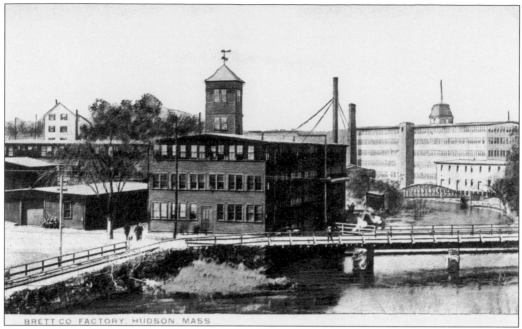

BRETT CO FACTORY, HUDSON, MASS

The C. M. Brett and Company factory, on the corner of Houghton and School Streets, became the Thomas Taylor Company in 1933, maker of woven webbing such as shoestrings, suspenders, belting, and "shugor." A walking bridge that spanned the Assabet River for workers to get to work from their homes is seen in front of the large building in the background. All the factories had many large windows since natural daylight was necessary for production. When electricity was finally available after 1890, it was of low wattage and scantily installed but soon became strong enough to allow many factories to escape from unpredictable waterpower to steady reliable electric power. The shoes made here were all nailed, making 5,000 pairs per day for boys and men. The bottom postcard shows the three-story addition built in 1901. (HHS.)

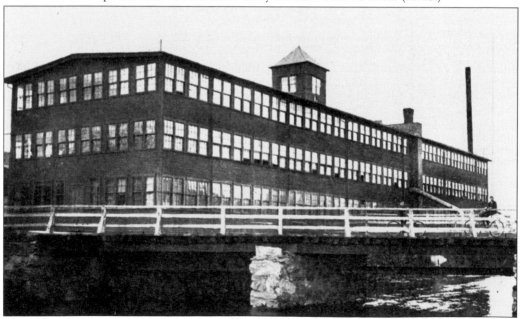

Four

PARADES AND CELEBRATIONS

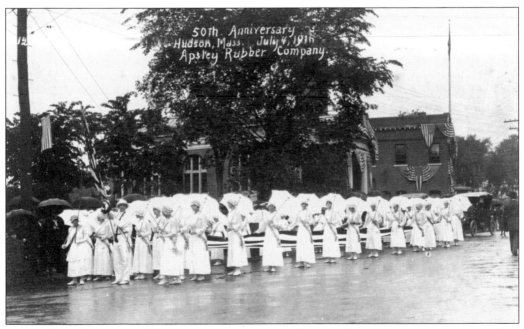

The 50th anniversary of Hudson was celebrated on July 4, 1916, with a large parade. Here women employees of the Apsley Rubber Company can be seen carrying a huge flag. It was a rainy day, but they were prepared with white umbrellas, which might have been planned as parasols for a hot sunny day. They are passing by the library and fire station, decorated with flags and banners. (HHS.)

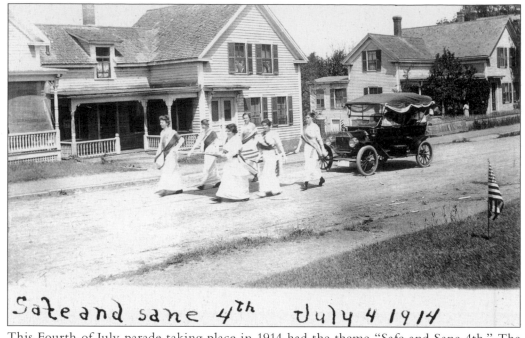

This Fourth of July parade taking place in 1914 had the theme "Safe and Sane 4th." The photographer was on Maple Street, which is now Manning Street. It was common for the Town of Hudson to have a parade every year on July 4 in the morning and picnics and baseball games in the local parks in the afternoon. (HHS.)

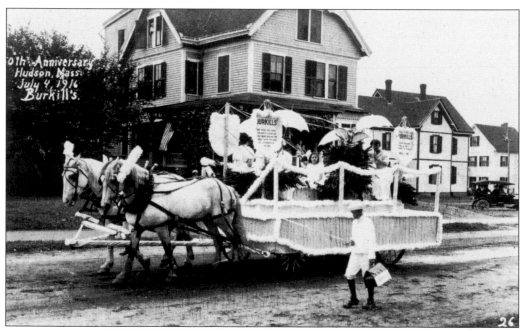

Even the horses are highly decorated for parades, as are seen by these two white horses drawing the Burkill Store's elaborate wagon. The parade was the Fourth of July parade of 1916, celebrating the 50th anniversary of Hudson. The picture was taken while the float was on Apsley Street near Lincoln Street. (PP.)

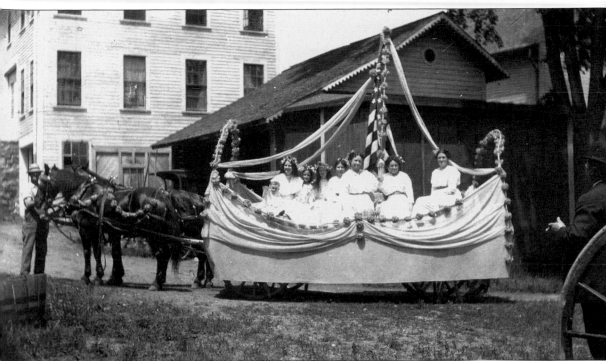

Shown above is one of the many elaborate horse-drawn floats posing for the photographer prior to the start of the Tuesday, July 4, 1916, parade honoring the 50th anniversary of the founding of the Town of Hudson. Besides the parade, one of the best features of the celebration was the exhibition at the armory that consisted of the products of more than 20 industries of Hudson. It was so interesting and it fit the occasion so well that people asked that it be held over until Thursday, July 6. People from many states and several foreign countries signed their names at this exhibition. Although the town's birthday was officially March 19 and there was a formal celebration that day at the state armory, the bulk of the celebrations took place at events scheduled on July 2 and 3, with the parade on July 4. (HHS.)

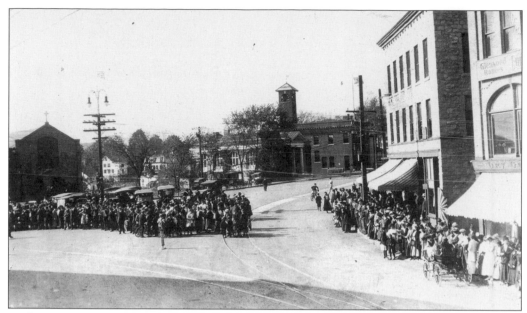

Hudson's Wood Square and Main Street was a location that all parades went through, regardless of the occasion, it being the center of town and having a lot of space for both marchers and observers alike. This postcard shows Wood Square looking toward the west and the Assabet River Bridge. (HHS.)

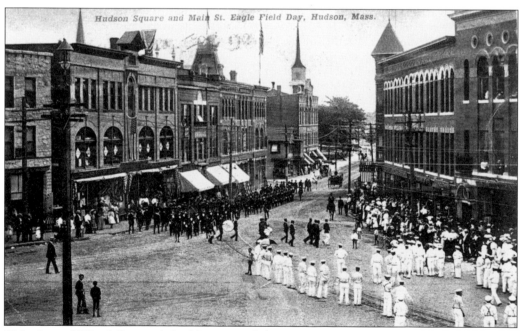

This view of Wood Square is looking toward the east and the town hall. The parade was in honor of Eagle Field Day. During the summertime, after Memorial Day, Hudson had a lot of summertime activities. Weekly band concerts were held in front of the town hall, and picnics took place on Pope's Hill, at Danforth's Falls, or at Lake Boon. (WB.)

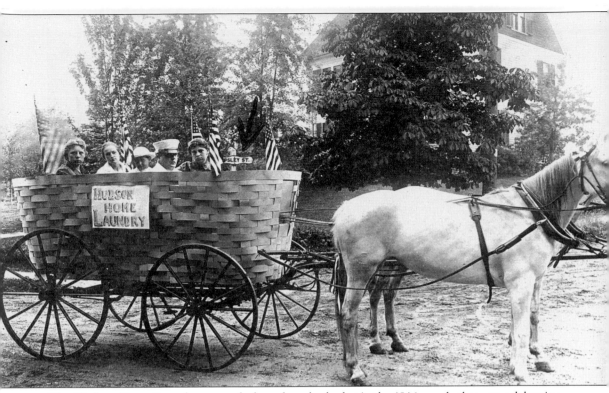

The Hudson Home Laundry entered a large laundry basket in the 1916 parade that was celebrating the 50th anniversary of Hudson. This float shown in the postcard above was labeled "Rub a Dub Dub, Many Men in a Tub." In 1913, the townspeople began to consider plans for a grand anniversary celebration to mark the town's 50th birthday, and in December 1914, the board of trade appointed a committee, consisting of Caleb L. Brigham, Arthur B. Howe, and George A. Coolidge, to look into the matter of a suitable program for such an occasion. On January 17, 1916, the town voted to raise $500 for this event. On Saturday, March 19, 1916, the celebration started at the state armory at 3:00 p.m. A grand chorus of more than 100 voices sang, and the Reverend Warren Francis Low, pastor of the Congregational Church, gave a historical oration. (HHS.)

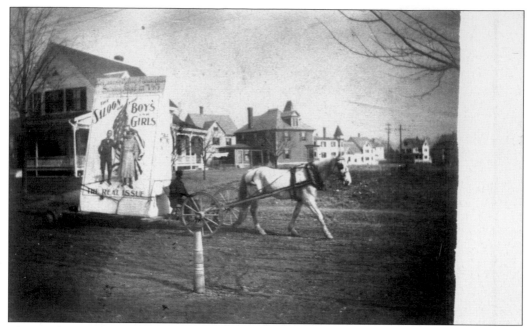

This single white horse is pulling a wagon containing a float labeled "Saloon" and was entered by the Boys and Girls Club into the Fourth of July parade of 1916, celebrating Hudson's 50th anniversary of its establishment as a separate community. The theme of the parade was "Safe and Sane 4th," and the parade itself was very large because of the special anniversary. (HHS.)

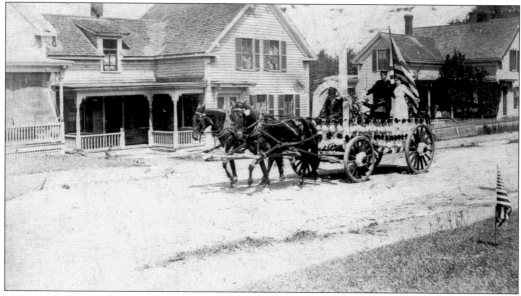

This lonely float drawn by a two-horse hitched wagon did not have an identifiable group entry but was part of the "Safe and Sane 4th" parade in Hudson held on July 4, 1916, and was celebrating the 50th anniversary of the incorporation of Hudson as a separate community, breaking away mostly from the town of Marlborough. (HHS.)

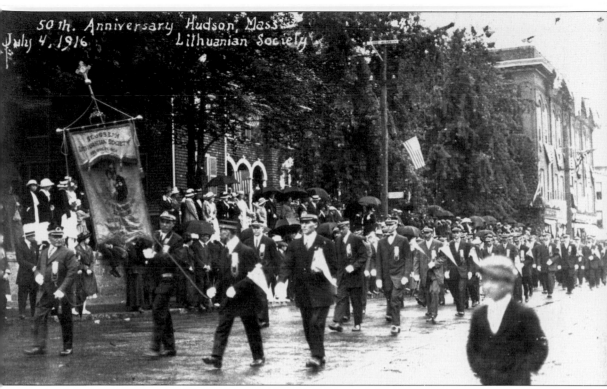

50th. Anniversary Hudson, Mass.
July 4, 1916. Lithuanian Society

Although the celebration of the 50th anniversary of the forming of the Town of Hudson was officially on Saturday, March 19, 1916, the Anniversary Committee continued the celebration on July 2, 3, and 4, 1916. A large tent was put up on the ball field on Florence Street, and the Honorable John F. Fitzgerald, grandfather of Pres. John F. Kennedy, and distinguished people from nearby towns and cities gave addresses. There were also musical entertainment and high-class sports on the grounds. On Tuesday, July 4, 1916, there was a grand parade in the morning consisting of the fraternal organizations, industries, and merchants of Hudson. In the afternoon there was a ball game. The weather on that day was stormy, but the parade and ball game still took place. Many horses and wagons lined up on Main Street, each carrying dignitaries, getting ready for the parade to start. In the picture above, the Lithuanian Society members march in the July 4, 1916, parade. (PP.)

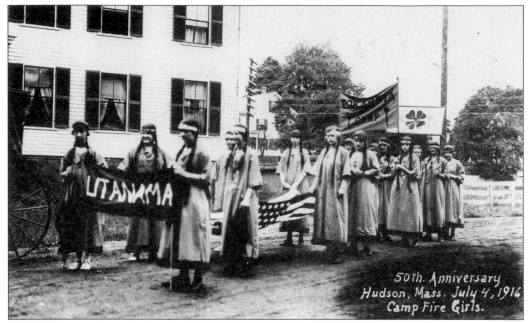

The Camp Fire Girls, Utanama tribe, are seen here getting ready to participate in the July 4, 1916, parade in Hudson of the 50th anniversary of the town's founding. Plans for this parade were started as early as January 17, 1916, when the town voted to raise $500 for the event, and an anniversary committee was formed. (PP.)

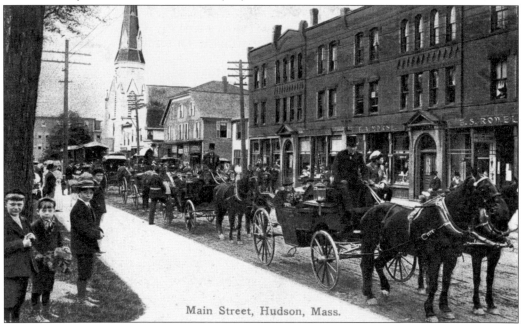

Main Street, Hudson, Mass.

Here is a large group of horses on Main Street teamed up with fancy horse carts with high-top-hat drivers at the reins to form a parade. Dignitaries appear to be in the back of each cart. The boys on the left of the postcard probably belong in one of the carts and are waiting for the parade to begin. This was probably the large July 4, 1916, parade that celebrated Hudson's 50th anniversary. (PP.)

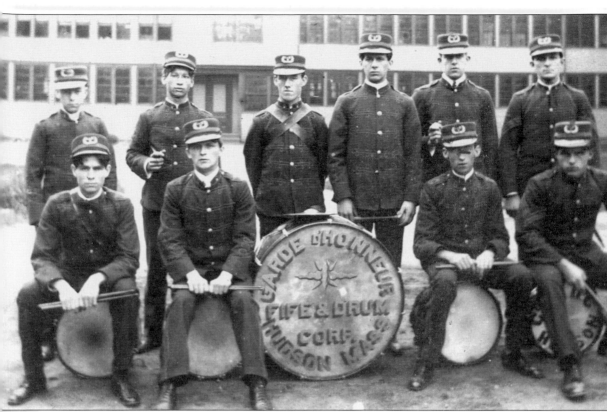

The Garde d'Honneur Fife and Drum Corps of Hudson was one of many bands and drum corps that were present in Hudson and provided entertainment for many activities in and around Hudson as well as in all their parades. Another area in which Hudson musicians were providing entertainment to the residents of Stow was as piano players or small bands that accompanied silent moving pictures. In Hudson, such movies were being shown at the town hall and at the opera house, with two performances each Saturday. Some of the movies that were being shown at those "theaters" were *The Birth of a Nation* and *Perils of Pauline*. Although these movies were entertaining, they reminded many in the audience that across the sea, the countries of their forebears were at war, and everyone wondered how that might affect the lives of the people even in Hudson. (PP.)

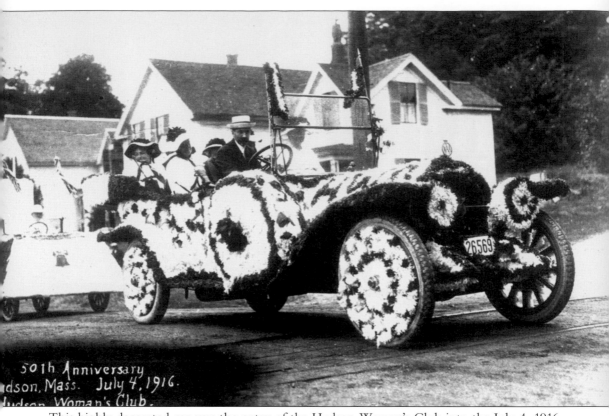

50th Anniversary
dson, Mass. July 4, 1916.
udson Woman's Club.

This highly decorated car was the entry of the Hudson Woman's Club into the July 4, 1916, parade celebrating the 50th anniversary of Hudson. It was believed that Bert Gleason was driving the car. Even the car's headlights were decorated to look like a pair of eyes. This special parade was populated by both horse-drawn floats as well as the fairly new automobile. The float behind this car is also built on top of an automobile. The roads were largely unpaved, consisting of hard packed dirt, which was quite suitable for horses but difficult for automobiles, especially when wet and muddy. One of the reasons that automobiles were becoming popular is because they did not need nearly as much maintenance, shelter, and food as did horses. Although horses were being seen less and less on the streets, they still had their place in the races at Trotting Park. (HHS.)

Five

OLD DOWNTOWN

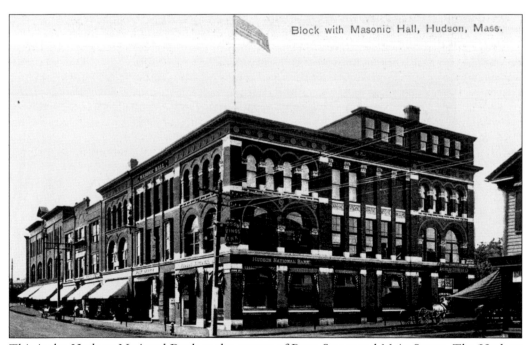

This is the Hudson National Bank at the corner of Pope Street and Main Street. The Hudson Savings Bank was on the second floor and is the owner of the whole building. On the third floor was the Masonic hall. In 2007, Avidia became the name as the Hudson Savings Bank expanded with branches in six adjoining towns. (VM.)

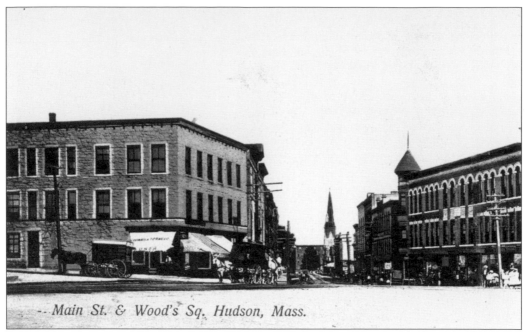

-- Main St. & Wood's Sq. Hudson, Mass.

This view of Main Street at Wood Square in Hudson is looking east and shows the Prescott building. The Prescott building is unusual in that it is made completely of granite blocks. It has a grocery store on the corner of Felton Street, and a delivery wagon is shown curbside in front of the grocery store, probably loading produce. (HHS.)

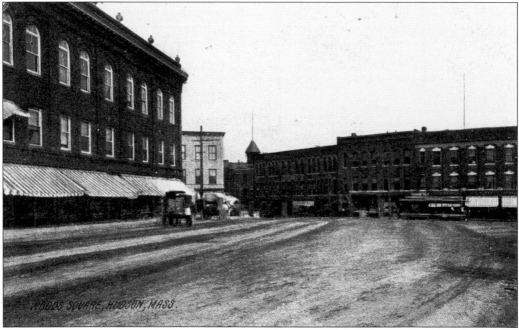

WOODS SQUARE, HUDSON, MASS.

Before Hudson's Wood Square was paved, its surface was all dirt, which was suitable for the horse-drawn carts and for the trolley tracks that supported several trolley lines that went through Wood Square, including those that went to Marlboro, to Concord, and to Clinton. The postcard above shows a trolley going toward Marlboro. (VM.)

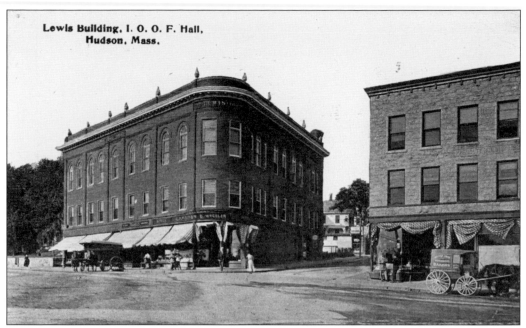

The Lewis building, on Felton Street at Wood Square in Hudson, was built in 1894 and featured the Carleton Wheeler drugstore (now Hudson Arts and Framing). R. B. Lewis established a photography business on the second floor, and he was an "artist of more than ordinary ability," known worldwide. The third floor contained the International Organization of Odd Fellows (IOOF) hall. In the picture above, the Prescott building is shown on the right and a horse-drawn wagon is waiting in front of it for a delivery. Next door to the west, Lewis built a four tenement house in 1882, and just beyond in 1878, he built a handsome estate. The 1894 fire destroyed both of his blocks but not his home. He rebuilt the four homes in Queen Anne style as well as this brick business block. (Above, WB; below, RO.)

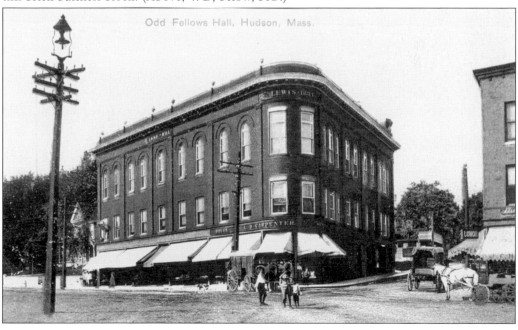

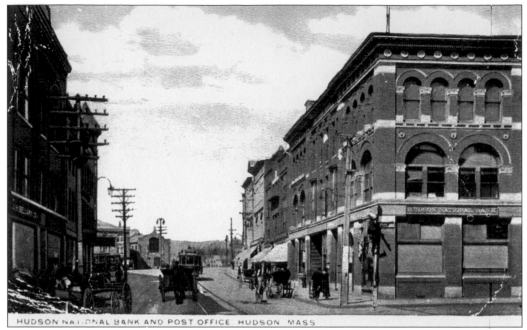

Showing on the right is the Hudson Savings Bank and post office in 1923. In the distance are St. Luke's Episcopal Church and a trolley car heading west toward Wood Square. The ornate Hudson Bank building used lion heads, human faces, and rosettes for adornment and featured many arched windows. (RO.)

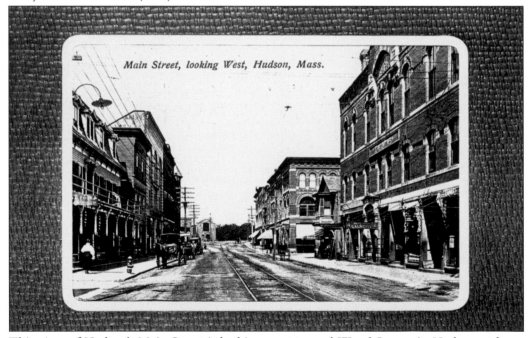

Main Street, looking West, Hudson, Mass.

This view of Hudson's Main Street is looking west toward Wood Square in Hudson and was taken about 1900. The trolley tracks running down the center of the street led to a transfer area in Wood Square where riders could transfer to other trolleys going to Berlin, Clinton, and Marlboro. (HHS.)

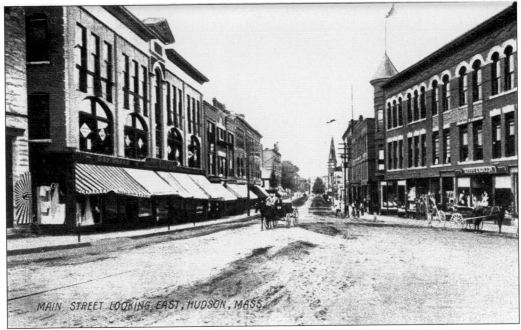

MAIN STREET LOOKING EAST, HUDSON, MASS.

Main Street looked like this if standing in Wood Square and looking east. Its dirt surface was sometimes full of pockets of mud and water, suitable only for horse-drawn wagons and carts. This picture was taken about 1909. The spire of the Methodist Episcopal church is seen on the right in the distance. Awnings were used to shelter the stores and goods from the southern sun. (VM.)

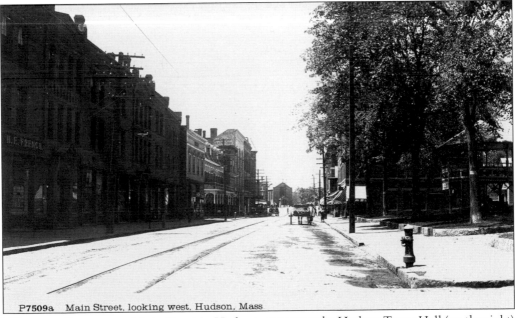

P7509a Main Street, looking west, Hudson, Mass

When traveling west on Main Street in Hudson, one passes the Hudson Town Hall (on the right) with its bandstand in front ready for a band concert or to be used as a reviewing stand when a parade passed by. On the left are many merchant buildings that were made of brick of similar style and were erected in 1895–1898 after the great fire of July 4, 1894. (HHS.)

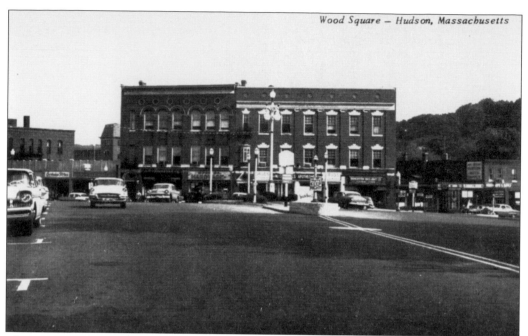

The Chase building dominates Wood Square in Hudson and now overlooks the square's traffic circle full of automobiles. The tower peeking from behind the brick block is the tower of the Ascutney Shoe Company on South Street that was burned in a huge fire of that entire company on October 31, 1971. (VM.)

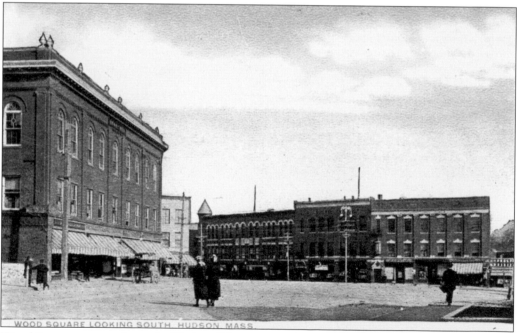

Wood Square, as seen from the Hudson Library, was a beautiful open area allowing for needed open space as the town grew and automobiles replaced the foot traffic, horse-drawn wagons, and trolleys. The man at the left is holding up the horse hitching post (or is it holding him up?). The ladies' shorter skirts would indicate that the picture was taken about 1910. (WB.)

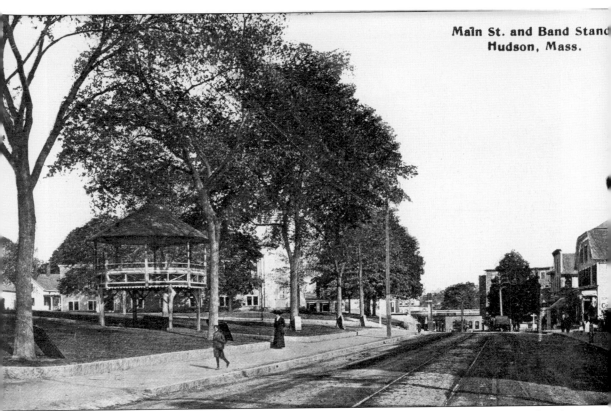

The bandstand showing on the left of this postcard is on the lawn of the Hudson Town Hall and was used not only for band concerts with the townspeople sitting on the large grass lawn but was also used by dignitaries to watch parades that always walked down Main Street toward Wood Square. The trolley tracks run down Main Street, which was still unpaved and often muddy. Note the formal wear worn by the ladies at this time (the postmark on the postcard was dated 1913). Note also the power lines on the right of the street and the telephone lines on separate poles on the left of the street. The board of public works has supervision of the entire system of electric light and power and of the streets of Hudson for which there are 84 miles. The street lighting system supplies current to over 400 streetlights as well as the current to operate the pumps in the sewerage pumping station. (PP.)

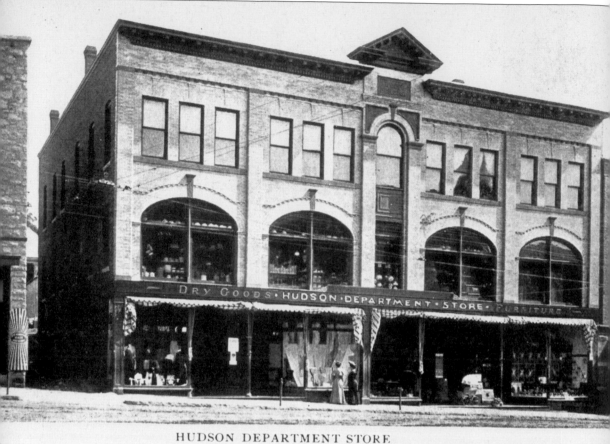

HUDSON DEPARTMENT STORE

The Hudson Department Store, on Wood Square in downtown Hudson, featured not only dry goods but also a large selection of furniture. Later part of this building housed a grocery store while the other part continued to sell furniture. Around 1950, the building housed the Crest TV and Appliance store and the four great arched windows on the second floor facing Main Street were covered by a large windowless sign that just said "CREST." This building was on the north side of Main Street, and one of its neighbors was the familiar and ornate Hudson Savings Bank building with the Masonic hall on its third floor. Awnings were very common on the north side of Main Street because of the direct exposure to the sun and covered the sidewalk from the building all the way out to the edge of the street. (HHS.)

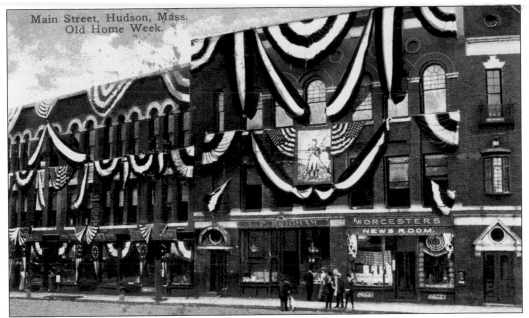

During Hudson's Old Home Week in 1916, most of the large buildings in downtown Hudson, especially on Main Street, were specially decorated with bunting and flags. The postcard above shows a string of Main Street merchants all decorated for Old Home Week. The postcard below shows the Hudson Savings Bank building on Main Street fully decorated for Old Home Week. The idea behind Old Home Week was to have a special day, usually in the spring, where all the former residents of Hudson would be invited to "come back home" to visit their old home. The merchants and the government buildings went all out to provide a celebration atmosphere for their visitors. Worcester's News Room became F. B. Fairbanks, selling and distributing newspapers, greeting cards, and small gifts. (Above, WB; below, HHS.)

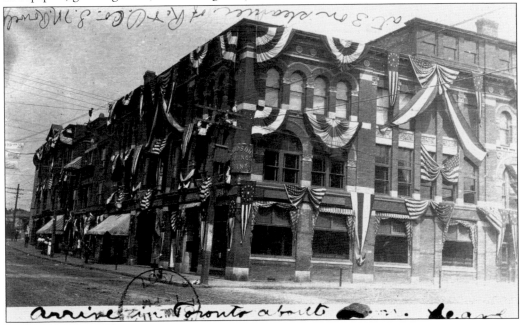

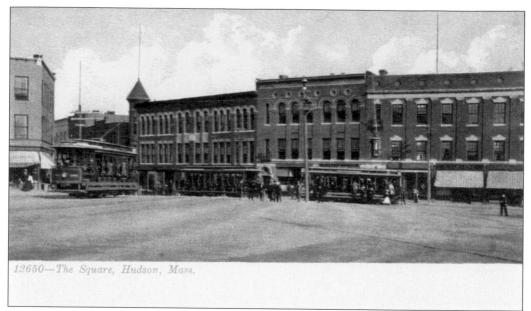

12650—*The Square, Hudson, Mass.*

Wood Square, seen here looking toward Main Street, was the termination of several trolley lines. Showing in this picture are three trolley cars—the Worcester Consolidated (Marlboro), the Concord, Maynard and Hudson, and the Clinton-Leominster trolleys—and they all happen to be open cars, very popular during the summer months. There were roll-down cloth blinds on the open trolleys that could be lowered if it was raining. Shoppers and workers could come to Wood Square from any of these towns, or use Wood Square to transfer from one trolley company to another. During the height of the trolley era, one could get to anywhere in Massachusetts by trolley if one knew how to traverse the trolley transfer system. (HHS.)

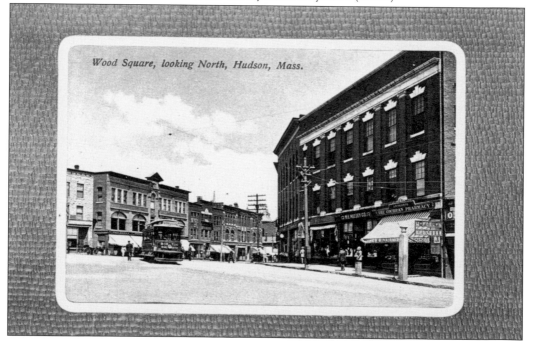

Wood Square, looking North, Hudson, Mass.

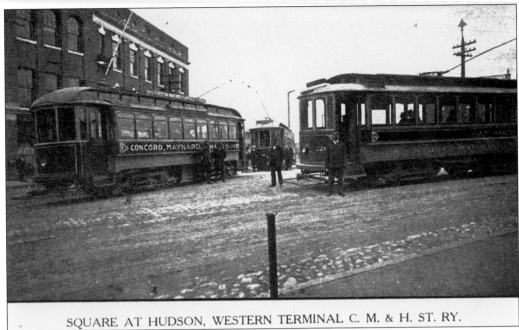

SQUARE AT HUDSON, WESTERN TERMINAL C. M. & H. ST. RY.

Wood Square in Hudson was a busy part of the town with its many people patronizing the many individually run shops in Wood Square and along Main Street. Many of those shopping at the stores got there by riding trolleys, as did those going to work at the many factories. Wood Square was the western terminal of the Concord, Maynard and Hudson street railway. (PP.)

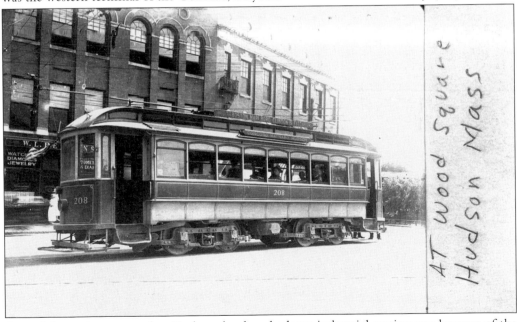

One of the main reasons that Hudson developed a large industrial section was because of the presence of two railroad lines both with stations in downtown Hudson. Hudson developed a large commercial section because of the presence of several street railroad (trolley) lines that all connected in Wood Square, making access to downtown stores very easy from many parts of town. (PP.)

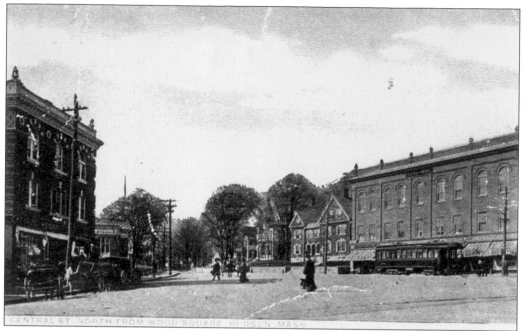

Looking down Central Street north from Wood Square in Hudson, the Chamberlain Block can be seen on the left. Frank Chamberlain formed a boot and shoe company nearer to the river where the 1894 fire started. This fire burned every building and home in the Wood Square area and down Main Street up to the town hall, on both sides of the street. (HHS.)

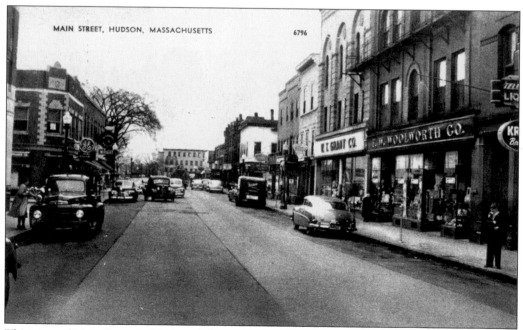

This view of Main Street in Hudson is from Wood Square looking toward the east. The street had many small stores on the first floor of the buildings and offices and apartments on the upper floors. Notice the competing Grant and Woolworth stores were right next to each other. (PP.)

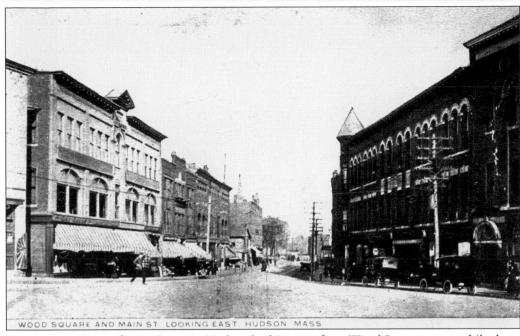

WOOD SQUARE AND MAIN ST. LOOKING EAST, HUDSON, MASS.

In these two views of Main Street in Hudson looking east from Wood Square, automobiles have replaced the horse-drawn wagons and carts, bringing Hudson into the 20th century. The Elks hall is shown on the right in both pictures. Some great automobiles modernized this picture below, taken in 1917. In 1901, the first "Knight Steam Carriage" appeared, made by Frank D. Knight and Son on Church Street. George (graduate of Massachusetts Institute of Technology in 1897) designed it and his father, Frank, did the machine work and assembly. They made and sold eight cars. Gasoline motor vehicles became more popular, but Knight and Son automobiles were the first made in Massachusetts. (Above, VM; below, WB.)

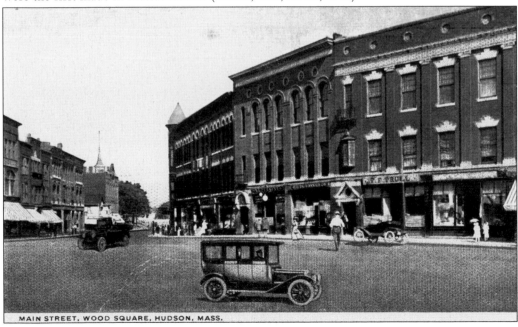

MAIN STREET, WOOD SQUARE, HUDSON, MASS.

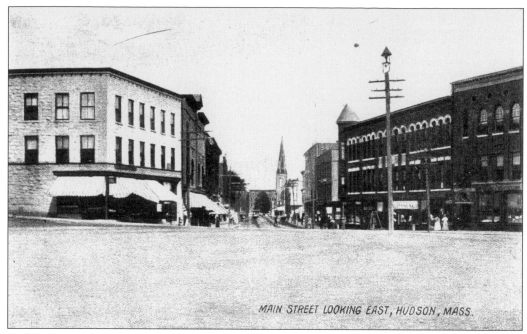

MAIN STREET LOOKING EAST, HUDSON, MASS.

Main Street is shown in this postcard looking east if standing in the middle of Wood Square in Hudson. The Elks hall is shown in the building on the far right. Wood Square featured a large single electric streetlight that attempted to illuminate the entire square and was one of the first electric streetlamps used in Hudson. (VM.)

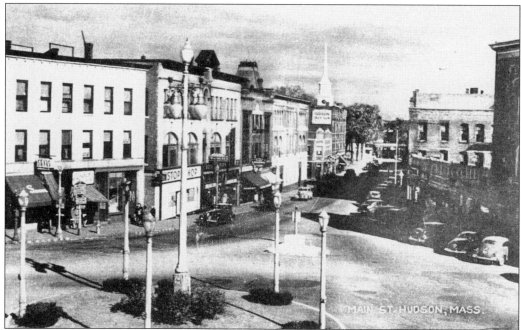

MAIN ST. HUDSON, MASS.

Wood Square, facing toward the east and looking down Main Street in Hudson, now replaced the pole with a single streetlamp, with a much taller metal streetlamp and flanked with six lower streetlights each on their own pole and cement base. This defined a rotary that helped organize the automobile traffic through the square. (PP.)

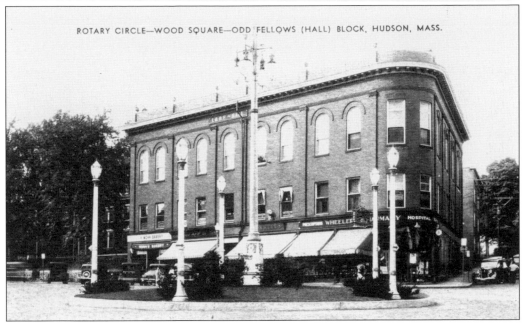

ROTARY CIRCLE—WOOD SQUARE—ODD FELLOWS (HALL) BLOCK, HUDSON, MASS.

The rotary in Wood Square was installed in the early 1950s in order to help keep the automobile traffic flowing in an orderly way through the square. All the trolley companies have gone out of business. The tall streetlamp in the square was replaced with a much brighter and ornate multiple-lamp unit. (PP.)

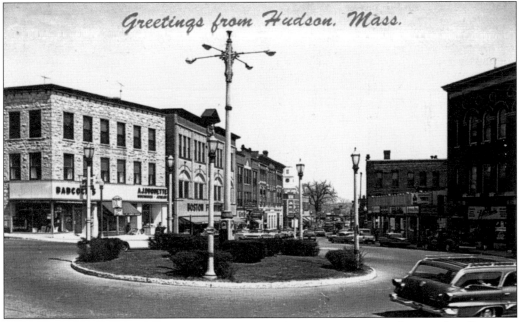

Greetings from Hudson, Mass.

Wood Square was the original site of Solon Wood's store, a very popular merchandise store in the town during mid-1800s. When it burned down in 1894, the town fathers showed great foresight when they purchased, for $10,000, the site of the store and eventually developed it into Wood Square. All the lights in the traffic circle have been replaced by more fancy-looking (and probably brighter) units. (PP.)

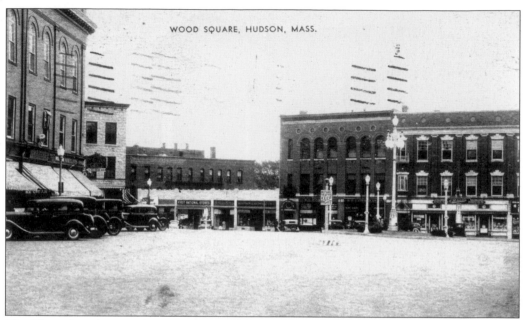

The Elks and Cochran Building dominates Wood Square in Hudson that now overlooks the square's traffic circle full of automobiles. Behind the brick block is the Ascutney Shoe Company on South Street that was burned in a huge fire of that entire company on October 31, 1971. (VM.)

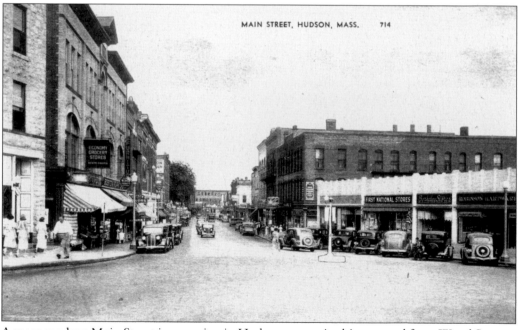

A more modern Main Street is emerging in Hudson as seen in this postcard from Wood Square. At the right, the upper levels of a three-story brick building, the Chase building, were burned in a 1935 fire and just the street-level stores were replaced, including a Sears store, the First National Stores grocery, Robinson Hardware, and Berkley Stores for women. (VM.)

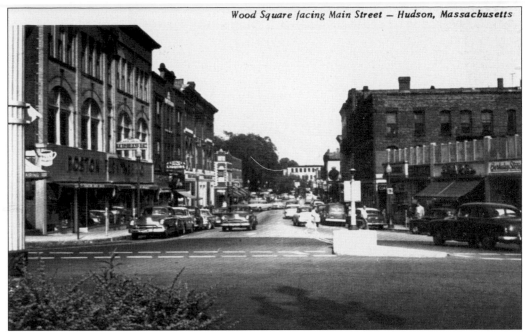

Wood Square, facing Main Street in Hudson, first had just a cement island with a caution light and a marked crosswalk for assisting pedestrians cross the wide square. Then as automobile traffic grew through the square, the cement island was expanded to include a large garden circle with tall streetlamps to make it safer for pedestrians who had to cross the street at this point in the square. (HHS.)

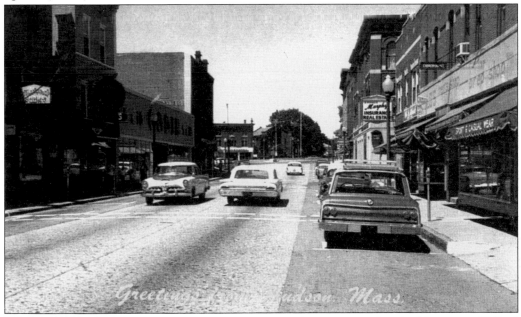

The relatively recent business district on Main Street in downtown Hudson looking toward Wood Square now supports many fancy streetlights and parking meters, something that a horse-drawn wagon and its driver never had to put up with. Pedestrians had to restrict their foot travels to sidewalks or marked crosswalks in order to get safely around town. (HHS.)

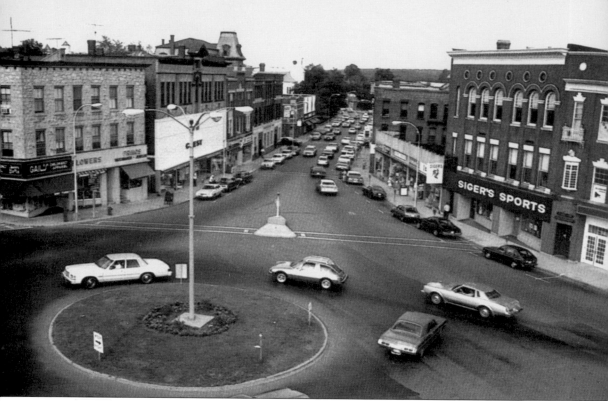

Here is a modern view of the downtown Main Street business district at Wood Square in Hudson around 1960. The cars are bigger and more prevalent. The streetlights have been changed, no longer able to support the Christmas lights that were strung to make a canopy of colored lights that Hudson was famous for. The rotary now has a huge, tall, lighted tree during the Christmas season. At the spot where this large streetlight now stands used to be the store of one of the first residents of this area, Jedediah Wood. A young man of 20, he started a store to conduct a cloth dressing business and passed on this store to Solon Wood, who expanded it into the Solon Wood and Company dry goods and grocery store. The town later purchased the store, removed it, and created Wood Square in its place. Wood Square is now recognized as the center of Hudson. (HHS.)

Six

THE BIG VIEW

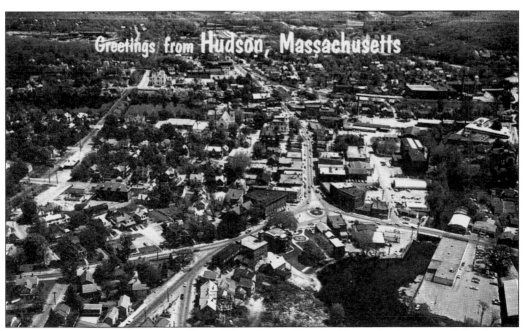

This recent aerial view of Hudson shows Wood Square like a bull's-eye in the center of the picture, which is appropriate since it is the center of town. The Assabet River can be seen in the lower right of the picture, and Bruce Pond can be seen in the upper left of the picture. (HHS.)

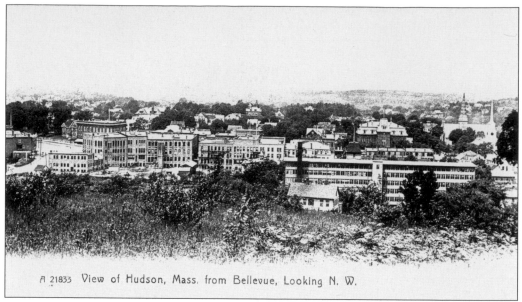

A 21833 View of Hudson, Mass. from Bellevue, Looking N. W.

This view of Hudson, from Mount Bellevue, is looking toward the northwest and shows the rear of the buildings along Main Street, now called South Street. Hudson Town Hall, which was built in 1872, can be seen to the right of center in this picture. Also seen is the rear of F. Brigham and Gregory factory along the Assabet River. (VM.)

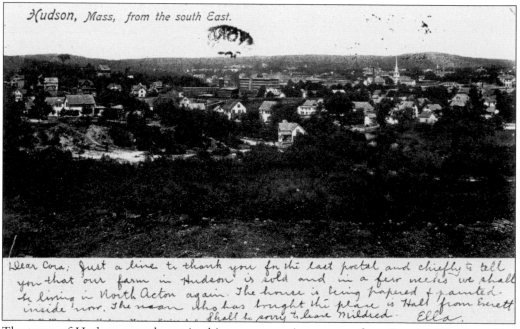

Hudson, Mass, from the south East.

Dear Cora; Just a line to thank you for the last postal and chiefly to tell you that our farm in Hudson is sold and in a few weeks we shall be living in North Acton again. The house is being papered & painted inside now. The man who has bought the place is Hall from Everett. Shall be sorry to leave Mildred. Ella.

The town of Hudson spreads out in this panorama view as seen from Pope's Hill (also called Mount Bellevue) when looking toward the southeast. The picture used in this postcard was taken very early, about 1860, before the F. Brigham and Gregory factory was built along the banks of the Assabet River. (VM.)

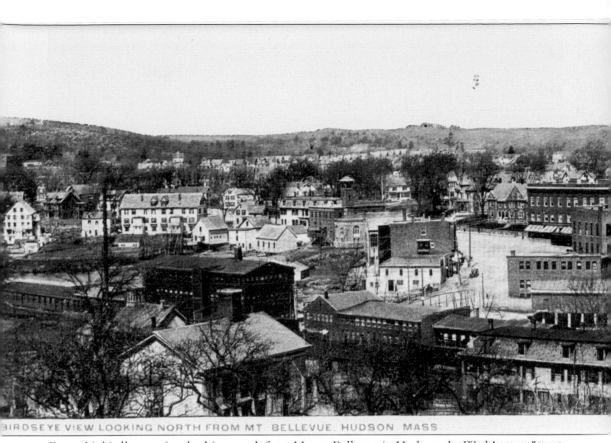

BIRDSEYE VIEW LOOKING NORTH FROM MT. BELLEVUE, HUDSON. MASS.

From this bird's-eye view looking north from Mount Bellevue in Hudson, the Washington Street Bridge can be seen crossing the Assabet River by the original F. Brigham Shoe Factories in the foreground. In 1857, Capt. Francis Brigham moved his little shoe shop across to the south bank of the Assabet River and raised the dam 20 inches to make more waterpower for his new mill, thereby enlarging the river basin. On the first floor of this mill building women's shoes were made, and children's shoes were made on the second floor. The factories had a large number of windows since without electric lights, the workers depended on sunshine to illuminate their workbenches. This building, called the "Old Red Shop," later became the Hudson Fabric Company, then Apsley and Coffin. The building was taken down in 1926 after the land was sold to Harvey Broadbent. (HHS.)

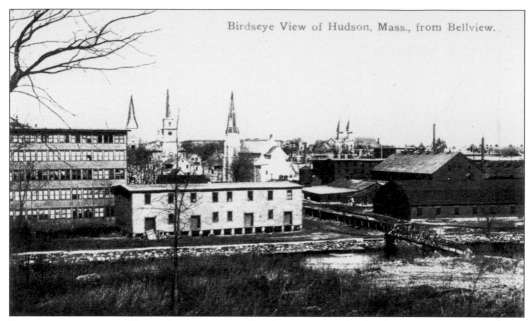

Birdseye View of Hudson, Mass., from Bellview.

Stone containment walls can be seen along the Assabet River in the foreground of this view of Hudson from Mount Bellevue. The steeples of many of Hudson's churches can be seen rising above the houses and factories in the town. The dye works factory, Dunn and Green Tannery, is showing toward the right. (WB.)

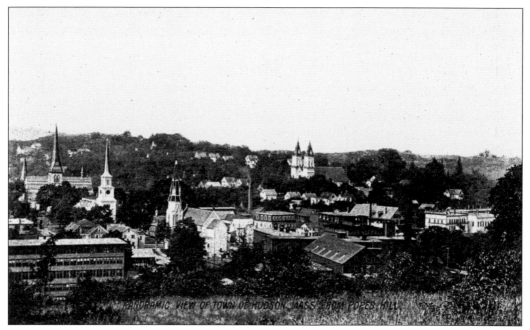

This is what the town of Hudson looked like from Pope's Hill sometime prior to 1911. The churches that can be seen, from left to right, are the Baptist church on Church Street, the Unitarian church on the corner of Church and Main Streets, the Methodist church on the corner of Main and Market Streets, and St. Michael's Church on Manning Street. (HHS.)

**Birds Eye View from Mt. Bellevue,
Hudson, Mass.**

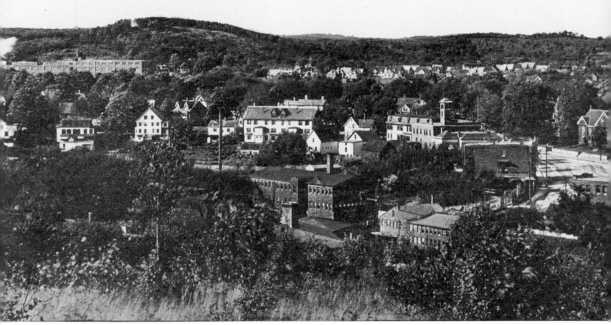

While standing on Mount Bellevue overlooking the town of Hudson, Wood Square is clearly visible on the right. The tower showing toward the right is on the firehouse next to Wood Square. The Apsley Rubber Company building is at the upper left, looking toward Phillip's Hill. The L. D. Apsley's rubber factory started in 1885 in a few buildings on Washington Street. But a fire made it necessary to rebuild, so in 1888, seven new buildings were constructed on Apsley Street. During the first 16 years of the business, the company manufactured only rubber cloth very successfully and in 1901 started to manufacture boots and shoes as well. During World War I, over half the factory was filling war orders, mostly for boots and rubber fabric. In 1921, the company became known as the Firestone-Apsley Rubber Company and became part of the Firestone Tire and Rubber Company of Akron, Ohio. (VM.)

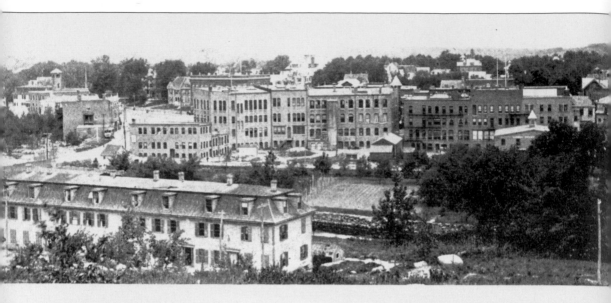

Way up on top of Mount Bellevue overlooking the town of Hudson, one can see in the foreground the shoe workers' family apartments. In the far upper left can be seen the tower on the fire station that was used to hang water hoses to dry evenly after a fire. Back in 1914, the firemen still used horses to haul their fire wagons to a fire. An unintended problem created by the horses

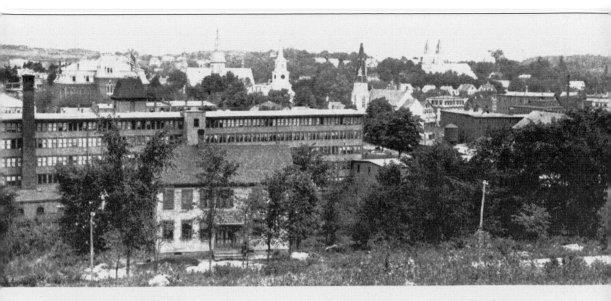

was what to do with their manure. The problem was not how to dispose of it but which of two government uses it should be applied. The Town Farm wanted the manure to use on its farm fields, and the electric power station wanted the manure for its lawn. It required an article at a town meeting to resolve the issue. (HHS.)

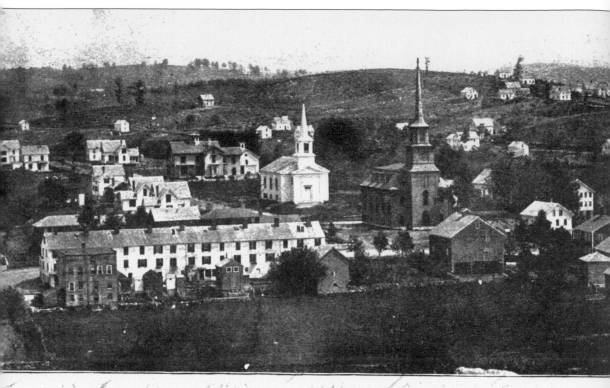

VIEW FROM POPE'S HILL, HUDSON, MASS., 1862.

By following Church Street with one's eye from Main Street (from left to right), one can see from Pope's Hill (also known as Mount Bellevue) in Hudson, the Brigham home on Church Street, the Baptist church (white) also on Church Street, and then the Unitarian church (brown) on the corner of Main and Church Streets. This is actually the way the village of Feltonville looked, since Hudson was not incorporated nor the name chosen until 1866. Union Hall, located inside the Unitarian church, was used for town meetings, having been built in 1861. The Unitarian church was originally called the Lawrence Church. Later the state legislature required that church buildings not be used to conduct town business, which led to the construction in Hudson of the town hall edifice that had not yet been built at the time this picture was taken. (WB.)

Seven

CHURCHES ON HIGH

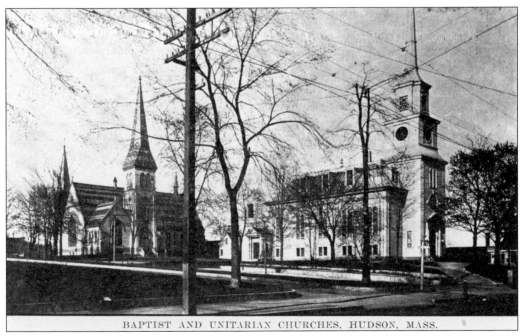

BAPTIST AND UNITARIAN CHURCHES, HUDSON, MASS.

The Baptist church (left) was built in 1871, and the Unitarian church (right) was built in 1861. The Reverend L. E. Wakefield was pastor of the Baptist church in Feltonville from 1845 to 1852. Rev. Wakefield's house was the present 58 Manning Street, and he was paid by the townspeople holding an occasional donation party. (VM.)

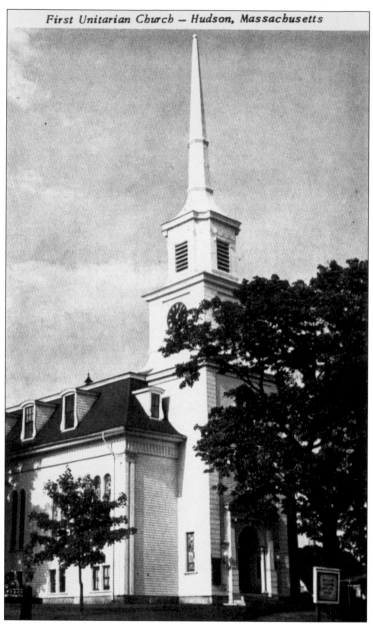

First Unitarian Church – Hudson, Massachusetts

The First Unitarian Church in Hudson was built in 1861 by a small band of liberal Christians called the Union Society, headed by Charles Brigham. Stephen Rice presented the society with a clock and requested that the building be called the Lawrence Church for his friend, Amos Lawrence. The church was dedicated on November 19, 1861. The church was originally painted brown and is the oldest church building in Hudson. In 1862, the vestry was named Union Hall, and town meetings were held there for six years until the town hall was built in 1874. At one time, the Masons and Odd Fellows held meetings here on the upper level. In 1890, the Union Society was changed to the First Unitarian Society of Hudson, now the Unitarian Church of Marlborough and Hudson, but the building is still the Lawrence Church. In 1892, the parlors were added, and a new pipe organ was donated. In 1964, the Sunday school wing was added in memory of Amble Tripp. (VM.)

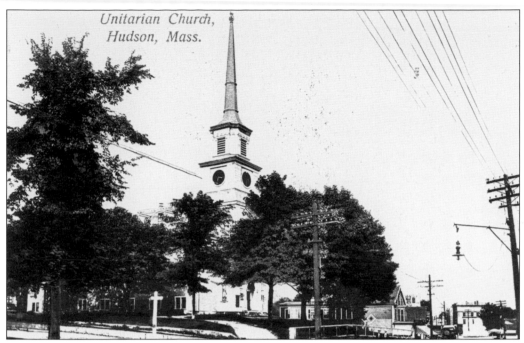

Unitarian Church, Hudson, Mass.

Located across the street from the Hudson Town Hall on Church Street is the Unitarian Church in Hudson, facing Main Street. It was originally called the Lawrence Church, for Amos Lawrence, was built in 1861, and in 1890, became the Unitarian Society. It is in this church that the first meetings were held by citizens of Feltonville desiring a "separate corporate existence" instead of being members of the Town of Marlborough. Directly opposite the church on Main Street was built the Methodist Episcopal church in 1867. To the left of the Unitarian church is the Baptist church, built in 1861. Note all the wires on the electric pole and the streetlamp. Electric streetlights were installed about 1890. (WB.)

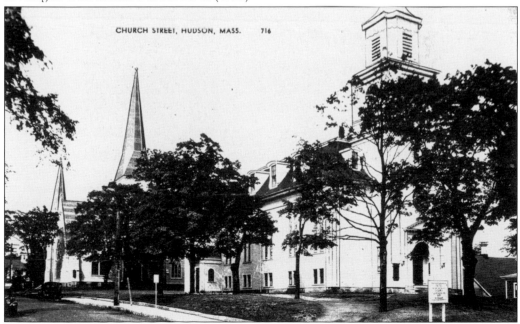

CHURCH STREET, HUDSON, MASS. 716

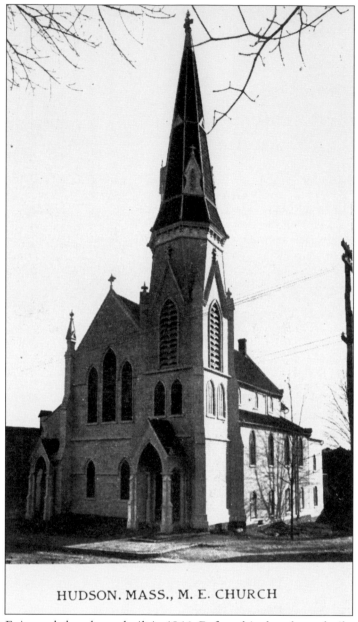

HUDSON. MASS., M. E. CHURCH

The Methodist Episcopal church was built in 1866. Before this church was built, the Methodists had services in 1810 and later a church building on Gospel Hill starting in 1828. People of the village of Feltonville, Stow, and Marlborough attended services in this little church on the hill. While a few of the congregation could ride to service in their chaises, the great majority walked the four miles or so. In those days, it was not an uncommon sight to see dozens of young maidens walking over the paths and dusty roads from Marlborough to attend Sunday services. It is related that these maidens usually carried their shoes and stockings in their hands and upon reaching the stone wall in front of the church would seat themselves on the wall and put on their stockings and shoes before entering the church. Besides saving shoe leather, it was also more comfortable to walk barefoot than it was to wear the stiff, harsh pegged shoes that the girls were obliged to wear at that period. (HHS.)

The Methodist Episcopal church, located in Hudson, was built in 1866. The church stands on the corner of Main Street and Market Street, across the street from the Unitarian church. The church was destroyed by a fire in 1911. Aubuchon Hardware store is now on this corner. The church was rebuilt after the fire at a new site on Felton Street. Market Street, where the church used to be, slopes down to South Street and to the Assabet River. A new park has just been finished in 2008 along Tannery Brook to be named the Argeo Cellucci Park, with walks, benches, a skateboard area, a splash pad, and a bocce court. (At right, VM; below, WB.)

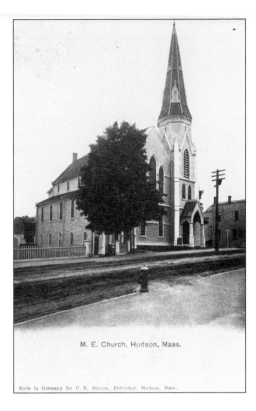

M. E. Church. Hudson, Mass.

Made in Germany for C. E. Saxton, Publisher, Hudson, Mass.

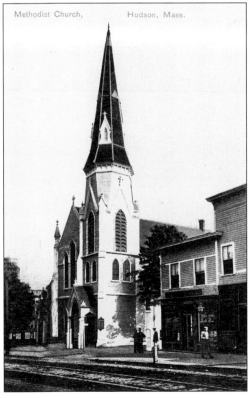

Methodist Church, Hudson, Mass.

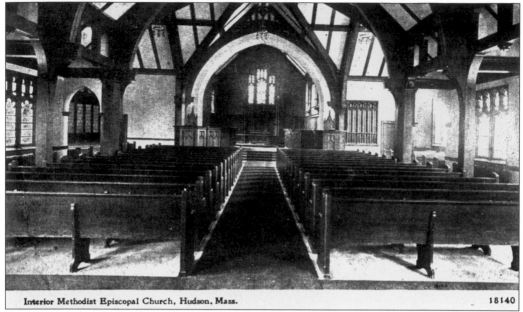

Interior Methodist Episcopal Church, Hudson, Mass. 18140

The interior of the Methodist Episcopal church in Hudson imparts a meditative atmosphere to those coming to pray. The sanctuary is arched with heavy oak beams and rough plaster walls of the Tudor style with a magnificent display of artisan skills and stained-glass windows. On June 15, 1913, the beautiful new edifice on Felton Street was dedicated and cost $40,000. (WB.)

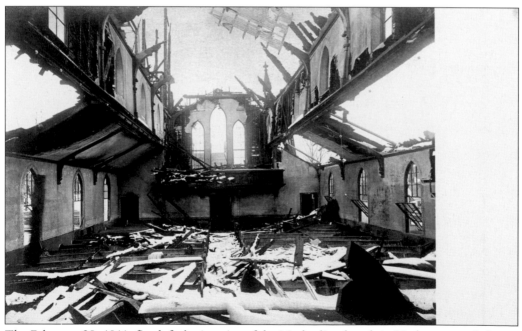

The February 28, 1911, fire left the interior of the Methodist church in Hudson a tangled mess that could not be rebuilt. The fire was caused by an overheated wood-burning furnace on a freezing Saturday night preparing for the Sunday morning worship that was to take place on March 1, 1911. (HHS.)

The nearby town hall provided a good location to view the Methodist church after the February 28, 1911, fire that completely destroyed the church. An overheated wood stove that was heating the church for the next day's service is believed to be the cause of the fire. Once the fire got started, the fire equipment available at that time was not capable of extinguishing such a fire and was primarily used to prevent the fire from spreading to the neighboring buildings. The arched windows were salvaged and were used again in a Thomas Taylor building at the corner of Houghton Street and Bellevue Avenue. (HHS.)

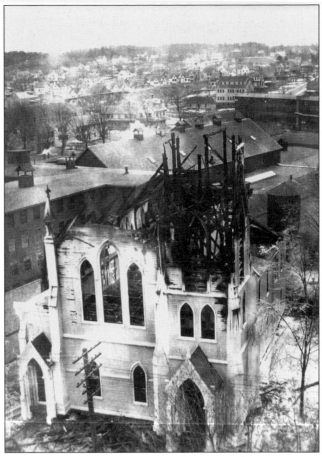

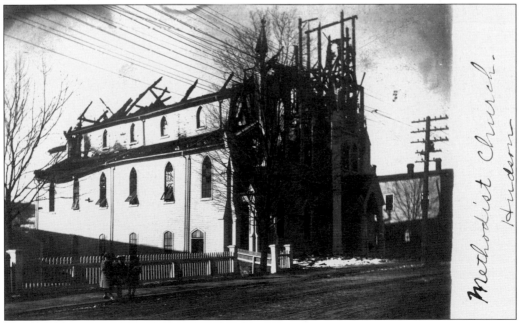

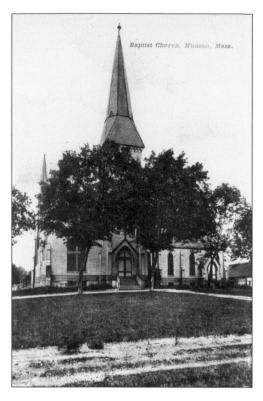

The original Baptist Society, and the first church in Hudson, was a small white church on Church Street. The church pictured here burned completely on September 23, 1965. The Unitarians offered their church for services. Sunday school classes were held in the old Hudson Hospital. In time, a new place of worship was built on Central Street. (RO.)

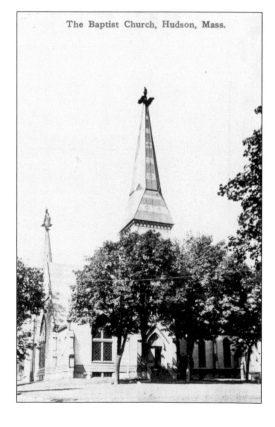

The shingles on the steeple of Hudson's Baptist church, built in 1919, had an interesting design. However, both steeples were felled in the 1938 hurricane, leaving a square-topped tower. After the 1965 fire destroyed the church completely, the Metrowest Boys and Girls Club of Hudson was built on this site. (HHS.)

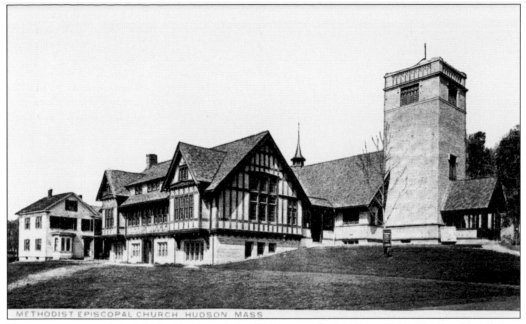

METHODIST EPISCOPAL CHURCH HUDSON MASS

The cornerstone of the Methodist church in Hudson was laid in June 1912. The land on Felton Street was given by L. T. Jefts and his wife Emily. Emily Jefts had a rose garden in the grassy triangle of land here on Felton Street. The church was dedicated in 1913. It is now the First United Methodist Church. (HHS.)

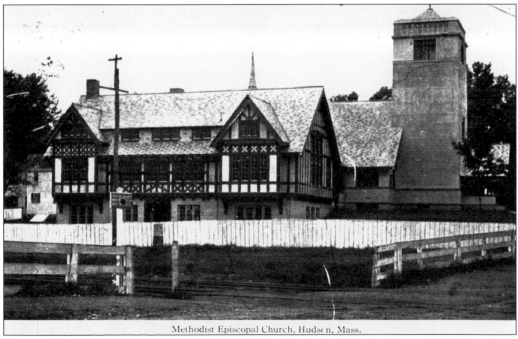

Methodist Episcopal Church, Hudson, Mass.

The fence around the First United Methodist Church in Hudson was supposedly erected as a boundary and protection from the railroad tracks that were in the backyard of the church. The tracks of this railroad led to Berlin and Clinton, and its railroad station was just across the street from the church. (VM.)

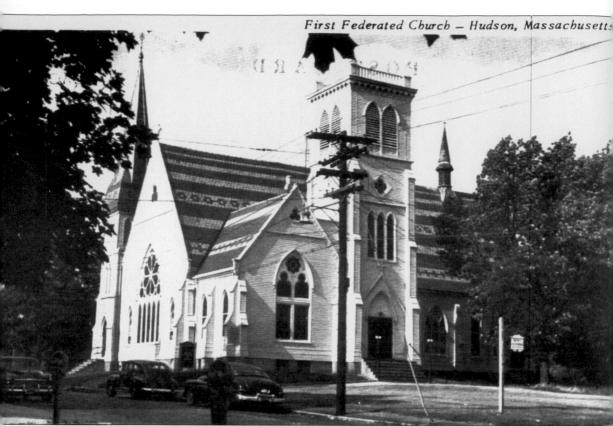

The Baptist Church of Hudson had its beginning in 1844, when Fr. Harvey Fittz came from Boston at the request of some people in Feltonville and for several months held preaching services here. In 1851, a meetinghouse had been built, and in 1877, the Baptist church building was dedicated. The church had a beautiful spire, but it was badly damaged by the 1938 hurricane. The Baptist church later merged with Congregational worshippers and became the First Federated Church in 1918. It completely burned on September 23, 1965, with an estimated cost of damage at $50,000 to $60,000. Soon after the fire, a nonsectarian committee was formed to assist the church in its rebuilding efforts. While a new church was being built, the Hudson Hospital was used for the church's school, and the Unitarian church was used to hold church services. The new church was built in 1967 and was located on the land of Halden Coolidge on Central Street. The Hudson Boys and Girls Club was built on the site of the original church. (VM.)

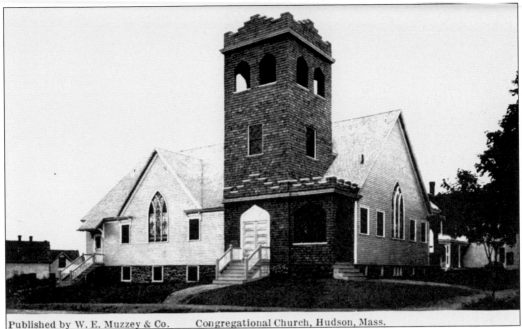

Published by W. E. Muzzey & Co. Congregational Church, Hudson, Mass.

The Congregational church in Hudson on Central Street and the corner of Green Street was built in 1902. On June 1, 1918, the Congregational Church merged with the Baptist Church to become the First Federated Church. This building then became a community hall, then a French church, then Christ the King Catholic Church. The church closed about 2004 and is now owned by Tighe-Hamilton Funeral Home on Central Street. (HHS.)

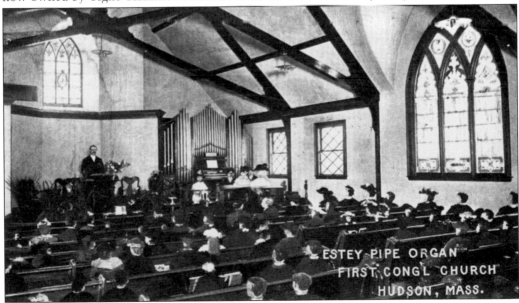

The large Estey Pipe Organ and the choir in the First Congregational Church in Hudson provided the music for services. The church is located on the corner of Central and Green Streets and was dedicated in 1902. During World War I, the Baptist and Congregational congregations worshipped together and in 1918 combined to become the First Federated Church of Hudson. This picture was taken before 1917. (WB.)

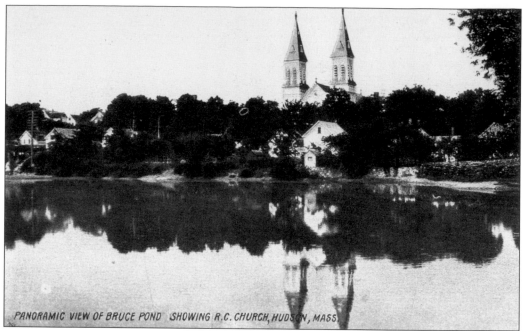

PANORAMIC VIEW OF BRUCE POND SHOWING R.C. CHURCH, HUDSON, MASS.

Here is a panoramic view of Bruce Pond showing St. Michael's Catholic Church in Hudson with its beautiful spires reflected perfectly in the still waters. When St. Michael's Catholic Church was built in 1891, the church had two spires that could be seen from every area, providing a comforting feeling for all townspeople. In 1938, a powerful hurricane devastated many of Hudson's trees and toppled the church's spires. Rather than replacing the spires, the church decided to build towers instead, which would not be as susceptible to hurricanes as spires. On September 29, 1918, St. Michael's Parish School was dedicated by William Cardinal O'Connell, and nine Sisters of Notre Dame took charge. A new convent on High Street was built to accommodate the nuns. (Above, HHS; below, PP.)

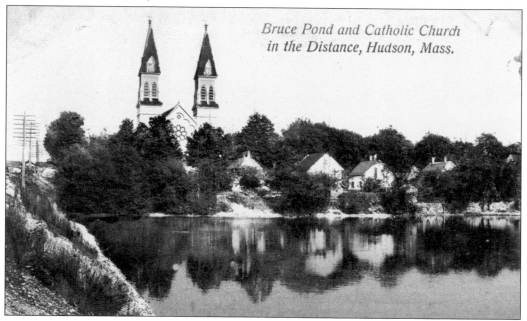

Bruce Pond and Catholic Church in the Distance, Hudson, Mass.

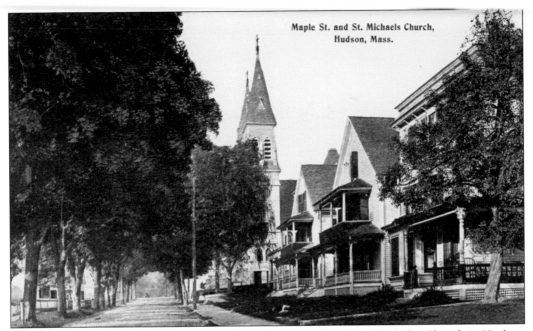

Maple St. and St. Michaels Church,
Hudson, Mass.

The trees form a canopy for Maple Street that led up to St. Michael's Catholic Church in Hudson that was designed by P. C. Kelly of New York and built in 1891. Maple Street was renamed Manning Street after the death of the Manning brothers, Ralph E. Manning and John W. Manning, in World War I. (WB.)

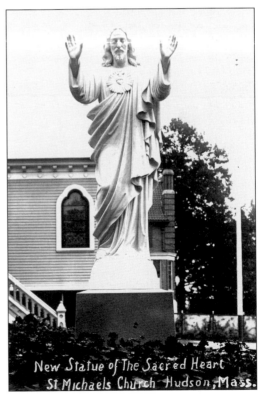

New Statue of The Sacred Heart
St Michaels Church Hudson, Mass.

This lifelike statue of the Sacred Heart at St. Michael's Catholic Church in Hudson stands like a sentinel by the side of the church. It has glorified the church grounds for many years and was a gift to the Reverend Michael J. Murphy, who took the position of pastor in 1908 until his death in 1939. The Sacred Heart statue was sent to Hudson from Italy. (HHS.)

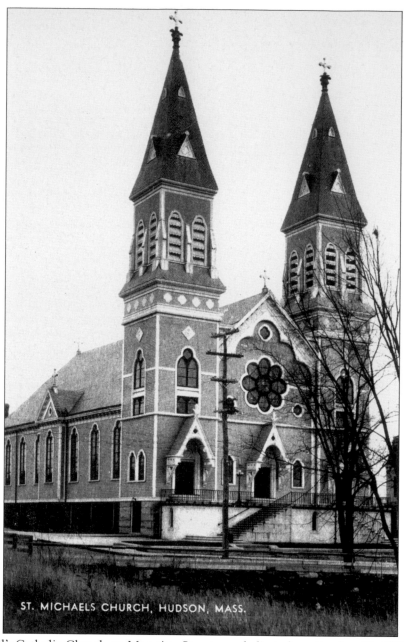

ST. MICHAELS CHURCH, HUDSON, MASS.

St. Michael's Catholic Church on Manning Street was dedicated on October 25, 1891. Initially the parish was formed in Milford, which included Catholics from the Hudson area. By 1857, Catholic mass was being said here in Hudson, in the homes of Patrick O'Neil on Main Street and Edward Merigan on Manning Street. A little later, services were held in Union Hall of the Unitarian church and in Houghton Hall. By 1869, there were enough Catholics in Hudson to purchase land on Manning Street and begin building a church. St. Michael's Catholic Church was dedicated as a mission church in February 1870. St. Michael's Catholic Church was named a new parish in 1876 and had its own priest. In January 1976, this parish celebrated its 100th birthday. The present St. Michael's Catholic Church building was begun in 1889 and dedicated on October 25, 1891. The earlier mission church was destroyed by fire in 1903. (HHS.)

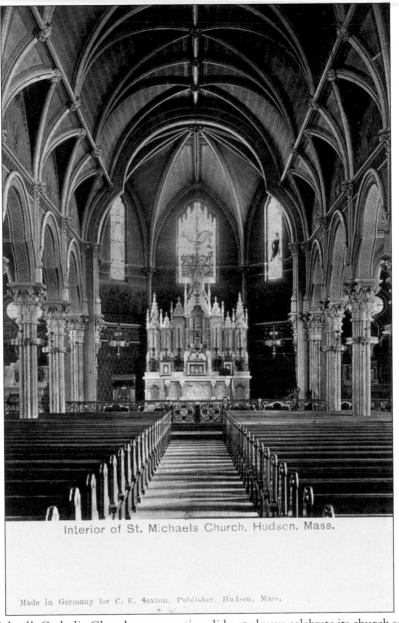

Interior of St. Michaels Church, Hudson, Mass.

Made in Germany for C. E. Sexton, Publisher, Hudson, Mass.

The St. Michael's Catholic Church congregation did not always celebrate its church services in a building as elaborate as this view of the interior of the current church would imply. James Wilson was the first Catholic to come to Hudson in 1834, and Thomas McKeinis followed in 1845. These two, along with Catholics in Marlborough, Ashland, Hopkinton, Maynard, Medway, and Holliston, formed the Milford Parish in 1846. These Catholics once a month gathered together in a private room in Marlborough where the Reverend Father Boyce celebrated mass. In 1851, mass was offered outdoors on South Street in Marlborough. By 1857, mass was occasionally held in the home of Patrick O'Neil and Edward Merigan in Hudson. Later mass was said in Hudson at the Union Hall of the Unitarian church and later in Houghton Hall. The first Catholic church in Hudson was a simple building on Maple Street in 1870. Construction of the current church started in 1889 and was dedicated in 1891. (BB.)

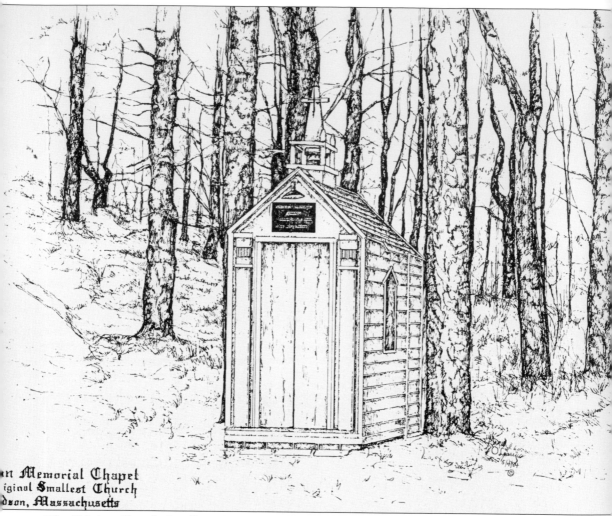

n Memorial Chapel
iginal Smallest Church
dson, Massachusetts

The "Union Church for all Faiths" was certainly the smallest church in Hudson, and perhaps the smallest church in the world with an ordained minister as pastor. It was built by Rev. Louis West at his home at 310 Central Street. Reverend West had used a small church at Stone's Corner, on the knoll at the end of Central Street, right beside the trolley tracks. So when one's trolley car came along, one could just step out of the church service and be on his way. The church is now located on Causeway Street, in a private yard. It was large enough for the minister and a congregation of two, or more likely a bride and groom. The diminutive chapel was at one time a waiting station used by patrons of the Worcester Consolidated Street Railroad located at Stone's carriage factory. (HHS.)

Eight

Town Buildings
and Memorials

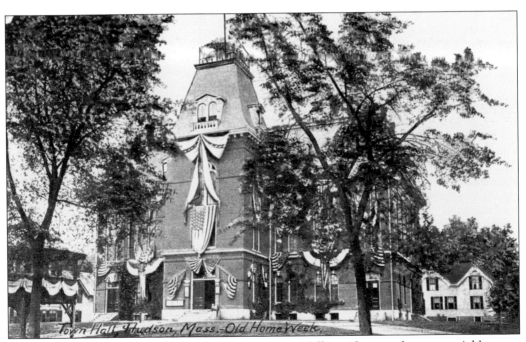

During Old Home Week in 1916, the Hudson Town Hall was decorated extra special because it was also the 50th anniversary of Hudson (1866–1916). In 1999, the renewed town hall was rededicated. Extensive renovations were made to the hall, including installing an elevator and redesigning the office spaces to accommodate computers, new business practices, and the increase in population to over 20,000 residents. (VM.)

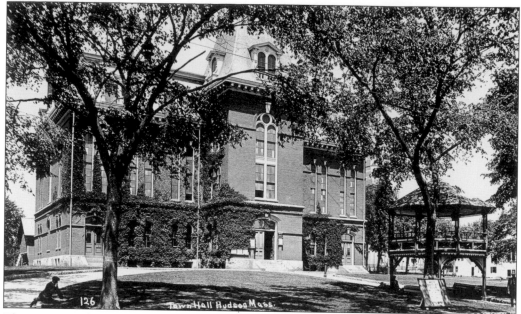

The governor of Massachusetts, Samuel W. McCall, viewed the 50th anniversary parade from the bandstand in front of the Hudson Town Hall on Main Street. There were many band concerts played at this bandstand (picture taken about 1914) during the summer season and they were free to all residents of the town. (PP.)

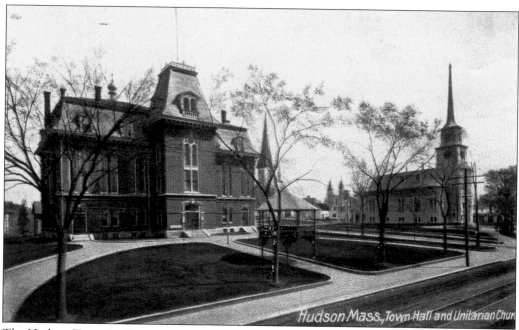

The Hudson Town Hall was located on the corner of Main Street and Church Street right next to the Unitarian church and was used for official town business. The building also housed the police department, the public library, and a large hall on the third floor used at various times as a courtroom, a Masonic hall, and a museum. (HHS.)

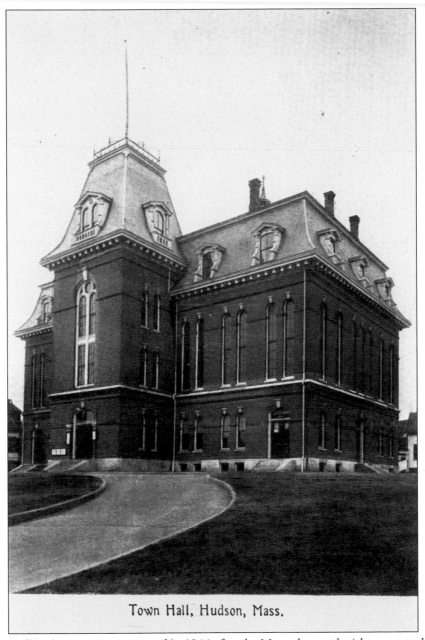

Town Hall, Hudson, Mass.

The Town of Hudson was incorporated in 1866 after the Massachusetts legislature voted to allow a separation from Marlborough. The residents lived in small white clapboard houses but chose to build this magnificent sturdy structure for their town hall. The base is made of Townsend granite, the walls are made of thick bricks, and the roof is covered with slate. On November 8, 1870, it was decided to purchase land for a town hall. On January 5, 1871, land on which the hall is situated was purchased for $10,000. On April 3, 1871, approval was given to prepare a design for a town hall; on May 18, 1871, construction began; and on September 26, 1872, the hall was completed at a cost of $43,000. An elaborate ceremony was held to dedicate the building in which C. H. Robinson, master builder, delivered the keys to E. M. Stowe, chairman of the board of selectmen. (VM.)

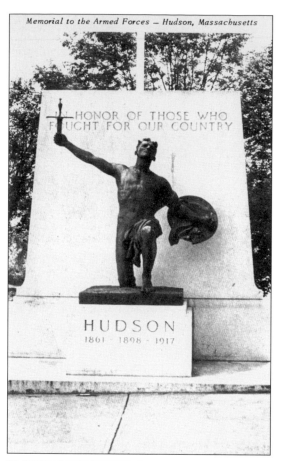

Memorial to the Armed Forces — Hudson, Massachusetts

IN HONOR OF THOSE WHO
FOUGHT FOR OUR COUNTRY

HUDSON
1861 · 1898 · 1917

The Hudson War Memorial is located just off Wood Square in Liberty Park and was sculpted after World War I out of bronze by John Gittardy to honor all veterans. On the back of the memorial is an inscription that reads, "In honor of those who fought for our country." A granite plaque, not shown here, was added in 1966 to each side of the statue, engraved with the names of servicemen from Hudson, one for World War I and one for World War II. In addition, Liberty Park, a small quiet place around the memorial, was created with a brick walk surrounding it. Each brick in this walk was engraved with a name and donated by families of the men being honored. (At left, HHS; below, PP.)

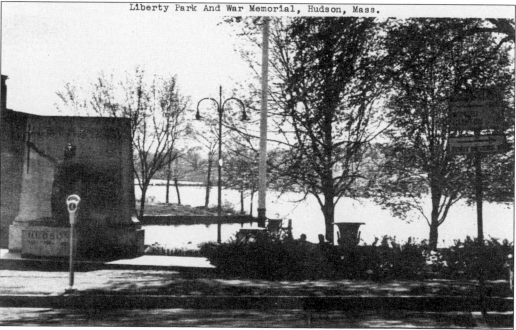

Liberty Park And War Memorial, Hudson, Mass.

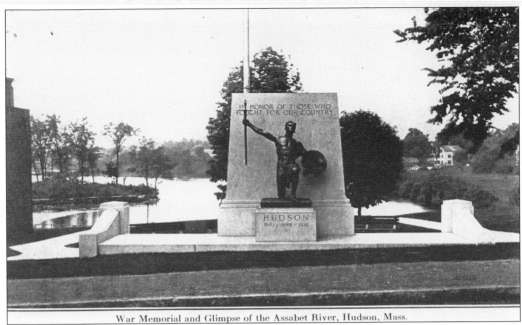

War Memorial and Glimpse of the Assabet River, Hudson, Mass.

The Soldiers' War Memorial built to honor those in Hudson who fought for their country is situated just off Wood Square located in the center of Hudson, next to the Hudson Library. The memorial was constructed after World War I. In 1966, a second memorial was added to the side of the original memorial, and the names of the veterans who died in the Korean and Vietnam Wars were inscribed on it. Behind the memorial is Liberty Park, which connects the memorial with the Assabet River and provides a quiet spot in the middle of the normally bustling activity of the town. (HHS.)

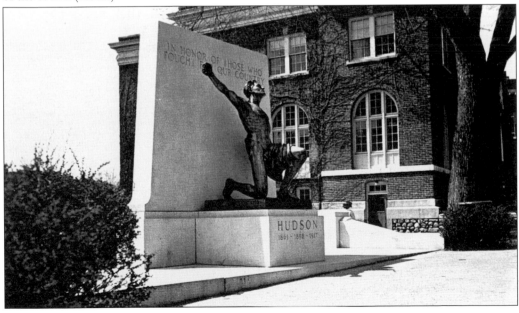

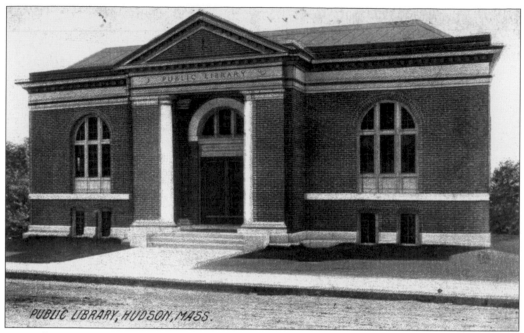

Soon after the Town of Hudson was incorporated in 1866, the Honorable Charles Hudson, for whom the town was named, offered a gift of $500 if the town would appropriate a matching sum to establish a free town library for the use of all the inhabitants. At the April 1867 town meeting, the proposal was unanimously accepted. With these funds, a library room was opened in the Brigham Block. (HHS.)

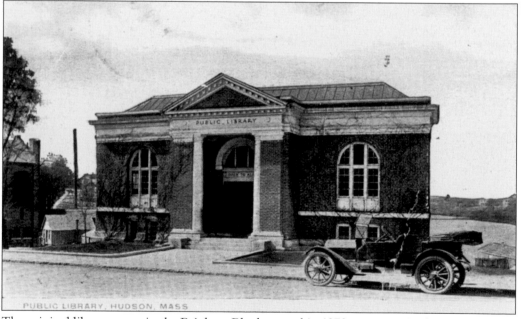

The original library room in the Brigham Block moved in 1873 to a room in the town hall. By 1903, an urgent need for more space prompted the librarian to contact Andrew Carnegie. His donation of $12,500 and $1,500 from the town financed the new library building, shown in this postcard, which opened in 1905. (HHS.)

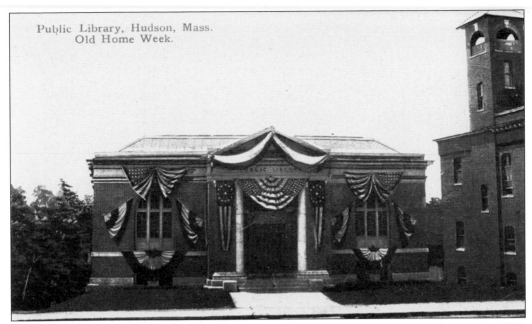

Public Library, Hudson, Mass.
Old Home Week.

The library was decorated in order to celebrate Hudson's 50th anniversary celebration in 1916. The Hudson Fire Station is on the right, and Liberty Park is adjacent to the library on the left, offering a quiet green space with benches for reading or enjoying a nice view of the Assabet River that is directly in back of the library. (HHS.)

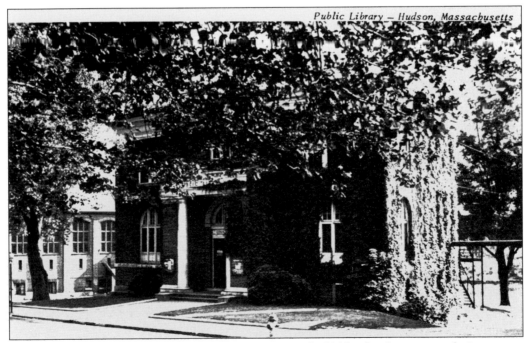

Public Library — Hudson, Massachusetts

On this postcard, the Hudson Public Library is partially hidden by the trees, and vines cover much of the upper floor of the library building. The flat roof was constantly leaking with costly repairs, so it was decided in 1916 to redesign the roof and add another floor for quiet study areas and to make space for the Hudson Historical Society Museum. (VM.)

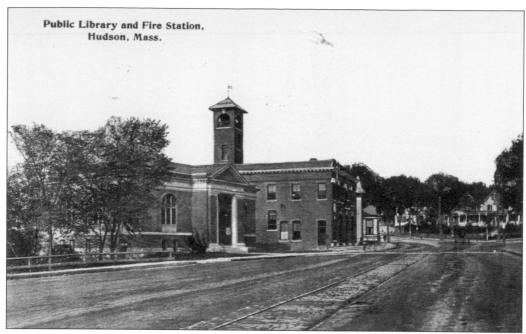

Public Library and Fire Station,
Hudson, Mass.

The Hudson Public Library and the fire station shown here are half of the group of special Hudson public buildings and monuments that are located together starting at Wood Square, considered by most as the center of Hudson. Across the street from the square is the Soldier's War Memorial to Hudson veterans. Behind the memorial is Liberty Park, providing a quiet spot between the bustle of the town and the flowing Assabet River. Next to the park and memorial is the Hudson Public Library, built largely by funds from Andrew Carnegie, then the old fire house, which used to house hand-drawn then horse-drawn fire engines before converting to motor-powered engines. (Above, VM; below, HHS.)

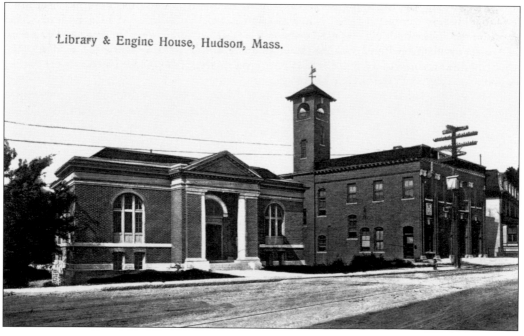

Library & Engine House, Hudson, Mass.

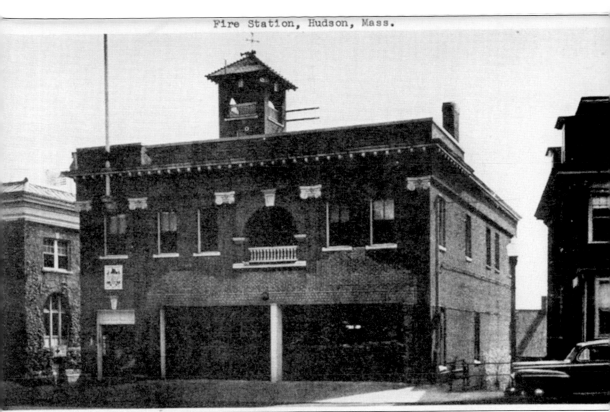

Hudson's old fire station, located in Wood Square adjacent to the Hudson Library, was built for the horse-drawn hose wagons, pumpers, and steam engine carts. The building also housed the horses used to pull the hose wagons and had everything needed to feed and take care of the horses. Eventually the firehouse was redesigned to accommodate fire trucks. It was not until 1884 that Hudson completed and activated its water system that included 186 fire hydrants. The tower on top of the building was used to hang the fabric-covered hoses for drying after a fire. The tower also had a bell to sound the alarm for a fire, and in 1893, a whistle replaced the bell, which made a test blast every night at 8:05 p.m. The children throughout Hudson were told to be home at night when the whistle blew. (PP.)

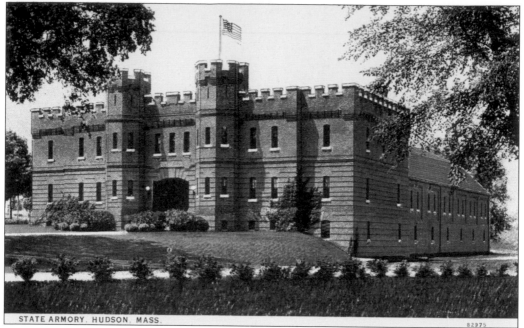

STATE ARMORY, HUDSON, MASS.

This state armory, built in 1910, is located in Hudson on Washington Street at Park Street at the site of the Marshall Wood home and is the headquarters of Company M. In 1899, the militia used the top floor of town hall for drills. Then the armory was moved to the opera house on South Street. In 1948, a large maintenance shed was built to the right of the armory and used to store vehicles and tanks. (WB.)

The National Guard armory, located in the center of Hudson near Wood Square, recruited many of its troops from the residents of Hudson, as seen in this postcard during a recruiting drive. Note the dress uniform used by most of the troops in this picture standing in front of the main entrance of the armory. (HHS.)

Members of Company M of the Hudson National Guard are shown at the armory after returning from the Mexican border on October 27, 1916. Company M was mobilized on June 19, 1916, and mustered into federal service on June 26, 1916, in Framingham. The unit arrived in El Paso, Texas, on July 2, 1916, to patrol the Mexican border. They were relieved on November 11, 1916. (HHS.)

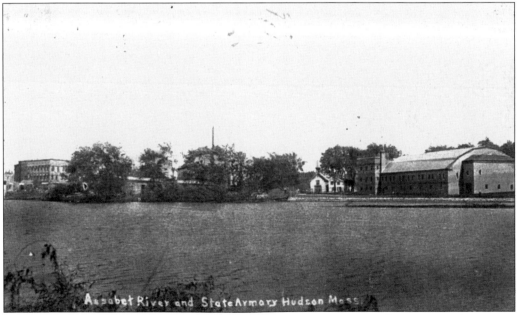

This is the National Guard armory in downtown Hudson as viewed from the Assabet River. This guard unit was originally organized on November 16, 1887, designated Company M and attached to the 5th Regiment, and reported for a nine-month encampment during the Spanish war. The armory was formerly located in the opera house, later moved to the upper story of the town house, then to its new state armory. (VM.)

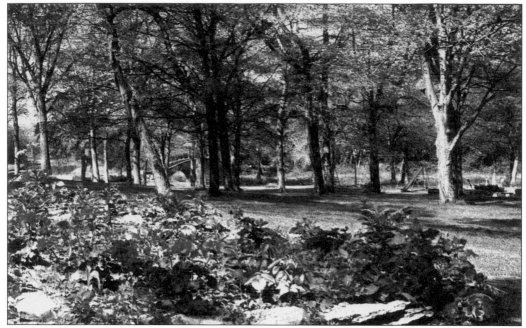

Wood Park in Hudson is located on the shores of the Assabet River. Marshall Wood presented this land to the town for use as a public park on June 9, 1896, although it was used as a park before then. It was here that townspeople had gathered for a Fourth of July picnic when the alarm came about 4:00 p.m. in 1894 that the town was ablaze. (HHS.)

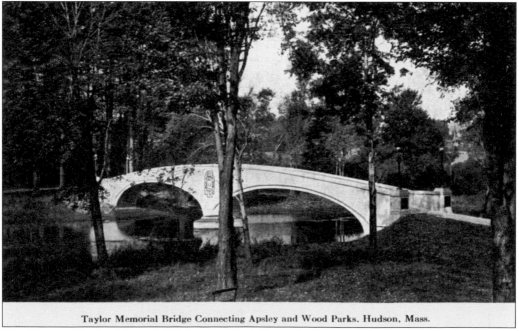

Taylor Memorial Bridge Connecting Apsley and Wood Parks, Hudson, Mass.

The Thomas Taylor Memorial Bridge on Park Street in Hudson connects Apsley Park on the west side of the Assabet River with Wood Park on the east side of the river. It was donated by Frank and Thomas Taylor of Thomas Taylor and Sons Company in 1927. Wood Park was the gift of Marshall Wood in 1896, and Apsley Park was the gift of Lewis D. Apsley in 1913. (WB.)

Nine

NATURE AROUND
HUDSON

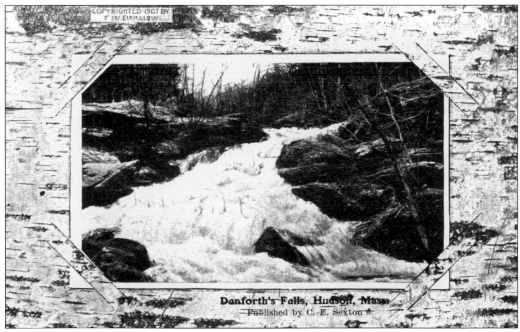

Danforth's Falls in Hudson is located just off Lincoln Street (Route 85) on the road to Bolton. The picture was taken about 1907 and is attractively printed on what appears to be a photograph framed with a birch bark border. A rushing flow of water is nature at its best. (HHS.)

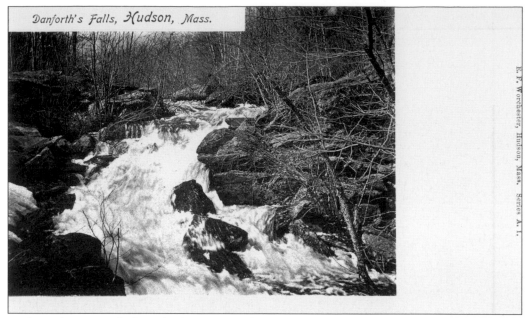

Danforth's Falls, Hudson, Mass.

In the early spring, before the leaves come back to the trees, spring rains cause the rivers in and around Hudson to flow very swiftly. This makes the scene at Danforth's Falls near Lincoln Street in Hudson very pretty, and it is a short walk that many nature lovers in Hudson take for their enjoyment. (HHS.)

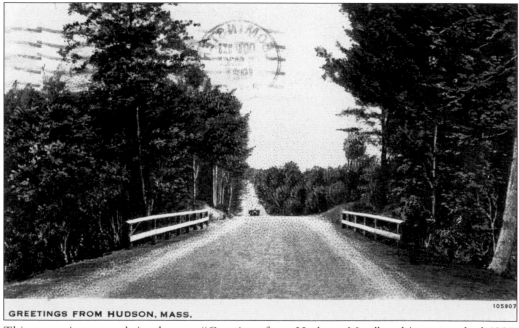

GREETINGS FROM HUDSON, MASS.

This souvenir postcard simply says, "Greetings from Hudson, Mass" and is postmarked 1927. Although it says "Hudson," it could be a scene anywhere and was probably printed with many different town names. In this scene, a car seems to be approaching a small bridge over a stream in the woods. (RO.)

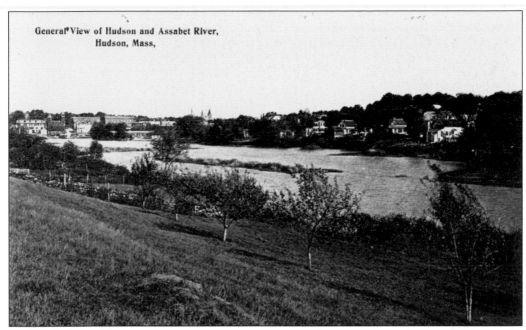

General View of Hudson and Assabet River, Hudson, Mass,

This general view of Hudson and the Assabet River flowing through Hudson shows the backyards of homes along River Street sloping down to the river's edge with their fruit trees, gardens, and very lush lawns. Across the river, wide and shallow at this point, are the homes on Park Street. (VM.)

The Town Farm (1906) was way out on East Main Street, almost to the Sudbury line. The residents tended gardens, chickens, and pigs, much as any family would with staples provided by the town. It was a haven for widows with children and the elderly. There was neither Social Security nor any other kind of aid. The Town Farm was closed and sold about 1940. (HHS.)

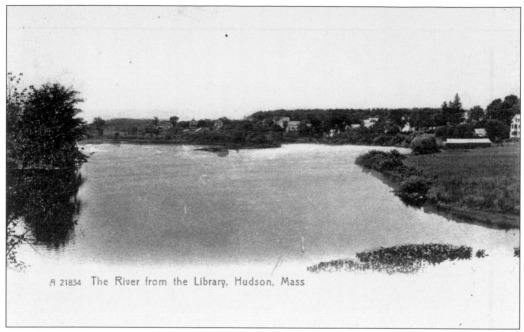

A 21834 The River from the Library, Hudson, Mass

The river is very peaceful in the lake behind the Hudson Library. By raising the Washington Street dam 20 inches to make more waterpower for the factories, the Assabet River basin was greatly enlarged for canoes and rowboats. Liberty Park and the Hudson War Memorial are near this scene and share the same view. (VM.)

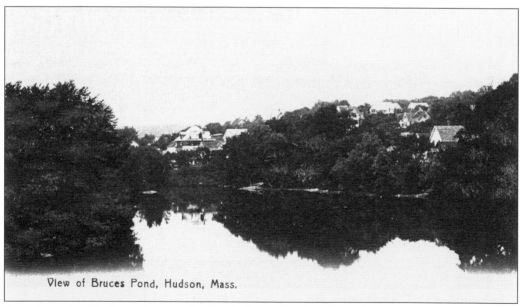

View of Bruces Pond, Hudson, Mass.

Bruce's Pond in Hudson is just north of Main Street, bordered by Lake Street. Larkin Lumber had a sawmill on the waterway that empties into the Assabet River by way of a very pretty waterfall. The dam behind the waterfall produced waterpower for the sawmill in the early days of the town. For many years, ice could be cut here each winter by Lamson Lumber and Ice. (HHS.)

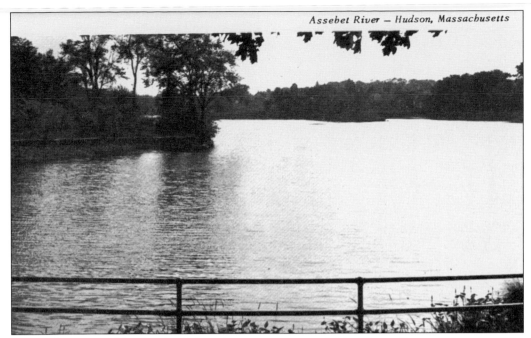

Assebet River — Hudson, Massachusetts

This is the scene of the Assabet River that greets anyone visiting the walkway at the rear of the library. Just above this on the grassy knoll is a cannon from World War I that the children love to climb on. It was rebuilt with new wooden wheels, cleaned up, and painted in 2005. At the left, the water heads to the Washington Street falls. (VM.)

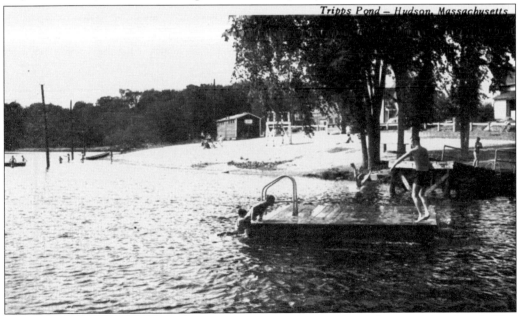

Tripps Pond — Hudson, Massachusetts

Tripp's Pond in Hudson is a spring-fed basin created by a wall and dam on River Road. This was the town beach for swimming and lessons until 1972 when Centennial Beach was opened at Fort Meadow Lake. Also a beautiful park with trees and flowers has been established, named Lamson Park. The Hudson High School ice hockey team practiced and champion team games were held here on natural winter ice. (HHS.)

Lake Boon is in the far eastern end of Hudson and is split between the towns of Hudson and Stow. It was formed by a dam that impounded water to be emptied into the Assabet River when needed by the large woolen mill in Maynard. After the mill converted to electricity, Lake Boon became a popular recreation area during the summers in the early 1900s. (VM.)

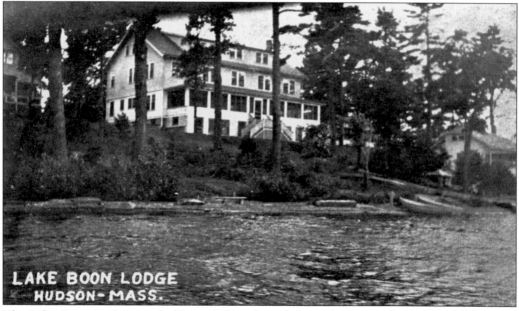

The Lake Boon Lodge was built in 1923 and was located in the southern (second) basin of Lake Boon in Hudson. During the summer, the lodge was very popular, being filled most of the time and providing a restaurant that was reserved by many local clubs and organizations for special functions and events. It burned down in January 1927 after being in existence for only four short years. (VM.)

Ten

THIS AND THAT

Our Seventeenth Annual,
Friday Evening, Feb. 14, 1896.

—— THE MEMBERS OF ——

RELIEF HOOK and LADDER CO., No. 1,

Of Hudson, Mass.,

Take pleasure in announcing to their friends and patrons that they will entertain all lovers of the terpsichorean art at Hudson Town Hall on the above date. All persons participating in the first five numbers are requested to appear in costumes.

A first-class Costumer will be at the Mansion House on Thursday evening, Feb. 13; also on the day of the party, with a full line of good, bad, and comic costumes at popular prices.

We take pleasure in announcing that we have engaged the services of the famous **Knowlton & Allen's Orchestra** of Natick, Mass., which is a guarantee that good prompting and fine music will be furnished.

This postcard was used as a way to announce the 17th annual dinner and concert in support of the Relief Hook and Ladder Company No. 1 on Friday evening, December 14, 1896. It was not uncommon for postcards like these to be used for announcements of major meetings or events. (WB.)

People in the past predicted that in Hudson's future, people would get around not only by using horses and wagons but also by using motorcars, steam trains, and a weird collection of aircraft and balloons. Their predictions were illustrated by this very unusual view of Main Street in the future. (HHS.)

This souvenir postcard for Hudson was probably used by many towns and cities by just changing the name on the flag. The young boy is calling from an old candlestick telephone. The postcard had a stamp cancellation date of 1913. (WB.)

106

Why did I waste so
many years,
In those other places,
dear,
When this is just the
loveliest spot
In the Western Hemi-
sphere.

Verse copyrighted 1912 by F. A. Hubold.

A very popular souvenir postcard in the early 1900s was one that had a small black-and-white picture in the top half of the postcard of a major place within the town being featured. The bottom half of the postcard contained a short poetic verse that was very complimentary of the town being featured but that never actually named the town. In these two examples of this style of souvenir postcard, the Hudson Library is shown at right located just off Wood Square, while the Fuller, Chandler and Patten Company's factory (formerly the Knott and Pope factory) located on Houghton Street is featured on the postcard below. (WB.)

One of Nature's beau-
ty spots,
It surely is right here,
And all is perfect but
the fact
That you arn't here,
my dear.

Verse copyrighted 1912 by F. A. Hubold.

FRED L. GIBBS

Photographer

All Kinds of Photos Except the Poor Kind

Picture Framing, Copying
and Enlarging, Crayons
Pastels, Water Colors
Amateur Finishing and
Supplies :: :: ::

Telephone Connection

38 Main St., Hudson, Mass.

Postcards were often used to advertise local merchants and their wares. This postcard promoted the work of local Hudson photographer Fred L. Gibbs and his photography studio. Notice the reference to "telephone connection," which indicated there was no telephone number, one just asked the operator to connect this telephone to Gibbs's telephone. (WB.)

HEADQUARTERS

Major A. A. Powers Camp, No. 5

SONS OF VETERANS, U. S. A.

All members of Camp 5 are requested to report at G. A. R. hall, Monday morning, May 30, at 7.45 o'clock SHARP. Bring white gloves and wear uniform if you have one, but COME ANY WAY, and show proper respect to the veterans of the G. A. R. by uniting with them in the sacred observance of the day.

Report at G. A. R. hall, Sunday P. M., May 29, at 3.30 o'clock. All patriotic organizations have been invited to attend Memorial Services at the Methodist church, through invitation of the Inter-Church League.

Drama in the town hall, Memorial Day evening, for the benefit of Reno Post 9, G. A. R. Buy all the tickets you can possibly afford, as the money goes for a good cause, and you are assured an enjoyable evening.

Per Order,
CARL L. BICKFORD, Commander.

GEORGE A. DERBY, Secretary.

Using a postcard to announce an event or an important meeting was common in the early 1900s. The one shown here requests the presence of the reader at Memorial Day ceremonies being held in the morning at the Methodist church, in the afternoon at the GAR halls, and later in the evening with a drama play being presented in the Hudson Town Hall. (WB.)

HUDSON LODGE, No. 64, A. O. U. W., HUDSON, MASS.

Grand Lodge Assessment No. 208 Lodge Assessment No 209: August 1. 1898—BROTHERS—The Grand Lodge has notified the Lodge of the following deaths:

NO	NAME	LODGE	NO	NAME	LODGE
2509	Andrew J McKenzie	Fernwood, 81, Mass	2524	Edgar E Howard	Rollstone, 107, Mass
25 0	Edwin A Scribner	Nathan Hale, 39, Conn	2525	Louis Philipp	Rockville, 18, Conn
2511	John P Ford	Marion, 66, Mass	2526	Charles W Palmer	Strafford, 2, N H
2512	Albert Berry	Pacific, 6, Mass	2527	Charles M Bryant	Prescott, 55, Mass
2513	Henry Abel	Winsted, 7, Conn	2528	James T Stidstone	North Shore, 68, Mass
2514	Eben Cass	Pioneer, 1, N H	2529	Albert Witham	Mountain, 88. Mass
2515	Marshall D Andrus	West Rock, 48, Conn	2530	Thaddeus H Wood	Glen, 141, Mass
2516	Carl Seelig	Myrtle, 15, R I	2531	William Jones	Crescent, 3, Me
2517	William E Hopkins	Maplewood, 139. Mass	2532	Walter I Mcgregor	Allston, 15 , Mass
2518	Nathaniel E French	Protection, 10, Me	2533	Michael J Burke	Dearborn, 8, Mass
25 9	Granville L Olds	Wahconah, 163 Mass	2534	Albert F Reeves	Ellsworth, 13, Me
2520	Edwin W Frost	W Roxbury, 156, Mass	2535	Arthur H Cate	Security, 8, N H
2521	Thomas S Loveys	Inman, 27, Mass	2536	Charles H Brown	Sterling, 46, Conn
2522	Frank Leonard	Bay State, 3, Mass	2537	John A Daly	Boston, 110, Mass
2523	Benj M Prescott	Pyramid, 45, Conn			

Assessment No. 208 has been called from the Lodge to the Grand Lodge Treasury, and Assessment No. 209 has been levied upon the members as advance assessment. You are hereby notified of the above levy, and to pay said **Assessment No. 209**, amounting to . . **$1.00**
on or before August 28, 1898, or you will stand suspended. **War Relief Call No. 1** .50

Received above assessment and War Relief Call No. 1 **Total, $1.50**

James A Lunt

JAMES A. LUNT, Financier

Here is another example of a postcard being used to provide common information to a large number of people. In this postcard, an assessment (dues) bill is being sent to all members of the Hudson Lodge of the Ancient Order of United Workmen (AOUW) in 1898. Notice that a war relief assessment is also included. The card also provided the lodge members with a list of all those in the Grand Lodge that had died recently. (PP.)

INSTITUTED AUGUST 2, 1886

HUDSON LODGE NO. 64. A. O. U. W.

REGULAR MEETINGS;
First and Third Mondays in G. A. R. Hall.

HUDSON, MASS., DEC. 13, '05.

BROTHER:

The next regular meeting of Hudson Lodge No. 64, A. O. U. W., will be held in **Town Hall,** Monday evening, December 18 at 7 o'clock sharp. After the business meeting there will be a social initiation. A first class visiting degree team will exemplify the work on 25 candidates. All the Grand Lodge Officers will be present.
Supper will be served in G. A. R. hall.
Music will be furnished by quartet and orchestra.
Be sure and attend.

A. B. ALLEN, MASTER WORKMAN.

ATTEST: J. E. FELKER, RECORDER.

In this meeting announcement, the members of the Hudson Lodge 64 of the AOUW are being invited to the next meeting (December 1905) being held at the Hudson Town Hall, and 25 new candidates to membership to the lodge will be initiated by a visiting degree team. The meetings were elaborate and included a meal and two orchestras. It was signed by the "Master Workman." (PP.)

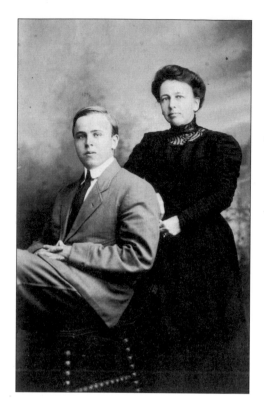

Seen here are Abbie Beede and her son Everett, both Hudson residents. Abbie was the daughter of Luman T. and Emily Jefts and married Frank Beede. L. T. Jefts died soon after his mansion on Felton Street was built, so the home is better known as the Beede mansion, an ornate brick structure. Frank was the superintendent of L. T. Jefts Shoe Company in 1884. (HHS.)

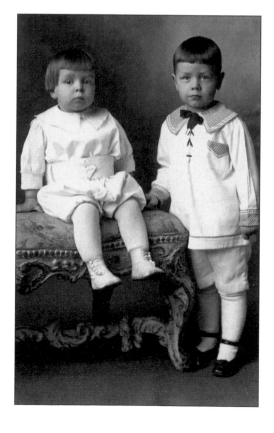

Thomas Trow Coolidge (four years old, on the right) is shown protecting his little brother Arthur Coolidge (two years old) in this postcard featuring a formal picture of the brothers made to mail to others in the family. The postcard was taken in Hudson in 1917. These are the sons of Hudson postmaster George Coolidge who lived on Packard Street. (HHS.)

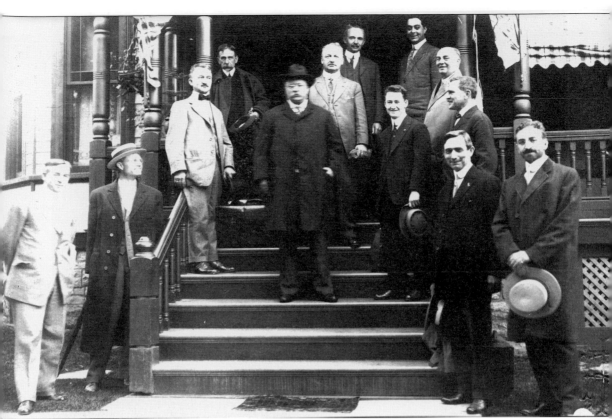

Dr. Fred B. Glazier (in the center) was surrounded by many of his friends on his front porch at his home at 12 Lincoln Street, corner of Rice Street, probably during a committee meeting of some sort. He was born in Waltham in 1859 and in 1883 began the practice of medicine in Hudson. He served as Hudson's doctor for 53 years and was also the town's moderator at 63 town meetings. Dr. Glazier was a member of the Hudson school committee, was elected as a Hudson selectman for 12 years, and was founder and first president of the Middlesex County Selectman's Association. He served on many other town boards and committees of the town and was prominent in the Republican Party, being a representative to the Massachusetts General Court for several years. In 1912, Dr. Glazier traveled with Pres. Theodore Roosevelt. (HHS.)

The postal employees met for this formal picture. The first post office was in Feltonville (1828) and was located in the Peters' Store. Then it moved to the Elks Club building. In 1889, a room in the Chase block was leased, and in 1894, operations were carried on in a building at the corner of Main and Pope Streets. The year 1902 saw the Hudson Post Office located in the Savings Bank building, then the Chamberlain block in 1931. In 1960, a new post office building was constructed on Church Street. Seen here are, from left to right, (first row) Edwin R. Willard, John J. Kerrigan, George A. Coolidge, Lizzie B. Bryant, and J. Arthur Wood; (second row) Lewis E. Ordway, William J. Busby, Joseph L. Lovett Jr., J. Edward McCarthy, and William H. Story; (third row) Richard Coolidge and N. Belanger. George Coolidge was postmaster from 1906 to 1935. (HHS.)

In 1912, Alfred and Eva Ordway had this picture taken and printed on a postcard showing Alfreda (four years old, on the left), Doris (two years old, in the center), and Louise (six years old) holding Edna Marion (one year old). Edna grew up to be Edna Wilson, school lunch manager for the Hudson Public Schools. They and a fifth sister, Betty, lived at the home pictured on page 16. (HHS.)

This properly dressed group of young adults gathered in the woods to pose for this picture at Gates Pond near Hudson. They are, from left to right, Ruth Coolidge, Grace (Brigham) Ordway, Rufus Coolidge, Bessie Danders Martel, George Coolidge, Lillian Coolidge, and Mabel Trow Coolidge. George and Mabel were the parents of the boys shown earlier. (HHS.)

Ruth Dakin Perreault and David Wheeler are performing in a dance recital in 1918. They are part of a group of 30 people, dressed accordingly, for a cotillion dance. They were the pupils of Benjamin B. Lovett, who had dancing schools in Ayer, Marlborough, and Hudson for 17 years. Henry Ford invited Lovett to teach his friends in Dearborn, Michigan, and built a beautiful dance hall for him in Dearborn. (HHS.)

Benjamin B. and Charlotte Lovett are seen here holding their dog. Benjamin graduated from Grant's Academy of Dancing in Buffalo, New York. In addition to dancing schools for young people, he taught adult classes at the Wayside Inn, Sudbury. Ford so enjoyed dancing that he enticed Benjamin to go to Dearborn to teach his friends. Ford built Lovett Hall, with a beautiful dance hall. (HHS.)

Rolla S. Lamson is seen here standing by his horse on Lake Street in Hudson. The R. S. Lamson Lumber Company used many horses in its business for general delivery of lumber, coal, and ice to its customers. During the winter, it also used the horses to help cut ice from local ponds into blocks that were used by its customers to put into their iceboxes before the days of refrigeration. (HHS.)

Parked in a driveway off the main street is a Knight Steam Carriage. In 1901, this first automobile appeared and was made by Frank D. Knight and Son on Church Street. They set up a factory in a 20-by-20-foot barn and in eight months' time finished manufacturing their first car. A total of eight cars were made and sold. Gasoline engines soon became more convenient. (HHS.)

The water was not very deep on Main Street during the 1936 flood of the Assabet River in Hudson, but it still flooded many basements and caused deeper flooding in other parts of the town. The kids all took off their shoes and had a great time walking through the water. Horses also had no trouble pulling their wagons through the water-covered road. (HHS.)

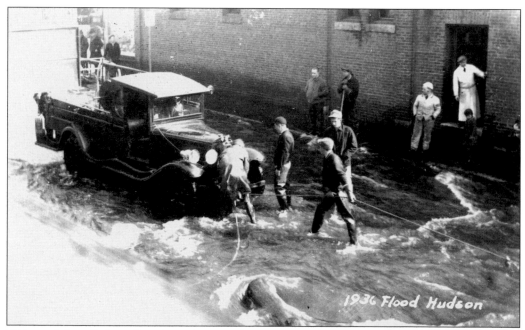

This truck is stalled on Houghton Street and Main Street during the 1936 flood in Hudson. The trucker is trying to start his vehicle by using a hand crank while others are standing by watching. The truck might have been one owned by the Hudson Power and Light Company with a spool of wire in the back of the truck and a siren on its front fender. (HHS.)

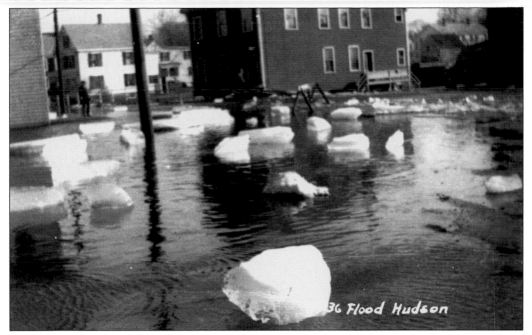

Ice is part of the flow of water down Broad Street during the March 19, 1936, flood in Hudson. Swift flowing ice can be dangerous to river bridges and can sometimes cause ice dams to be formed that back up the water of the river, causing flooding behind the dam. (HHS.)

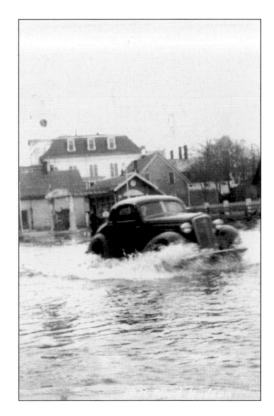

The car is trying to head east on Main Street during the 1936 flood in Hudson. Older cars were not as good at shedding water splashes as are today's cars. This car probably stalled soon after this attempt to drive through the floodwaters as the water splashed up over the car's sparkplugs. (HHS.)

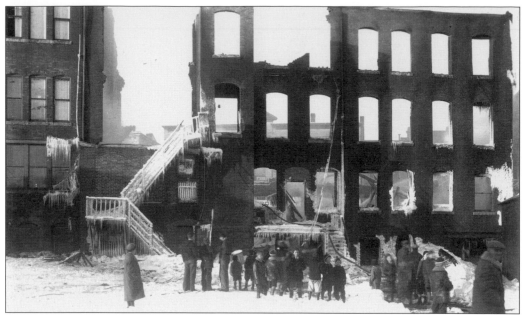

Firemen and onlookers view the rear of the Chase block during the Chase block fire on February 7, 1935, in Hudson. The value of this building was estimated at $200,000. The Hudson Fire Department was assisted by those of Marlborough, Stow, and Berlin. All 37 tenants of the apartments on the second and third floors were evacuated, including two invalids and three children with chicken pox. (HHS.)

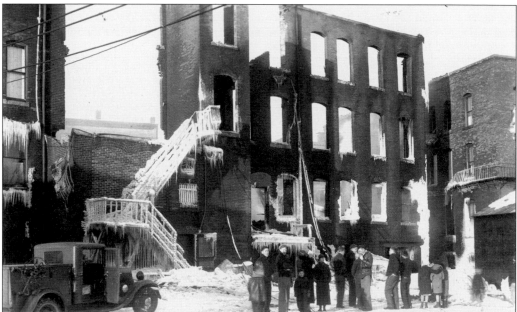

This is all that was left of the rear wall of the Chase block after the fire in February 7, 1935. Robinson Hardware was a tenant on the first floor and had stored ammunition for sale that the fire set off "like popcorn" causing spectators to duck for safety. The stiff wind carried embers to adjacent buildings, keeping the firefighters very busy to prevent them from also burning. (HHS.)

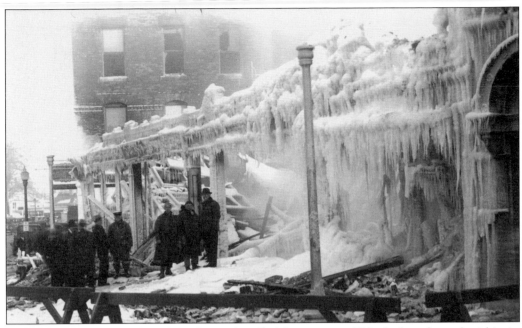

The Chase block, even though built mostly of brick or stone, still had a lot of wood within its buildings, often soaked with oil and other flammable droppings from the industry that occupied them; this, combined with the absence of watchdogs as fire alarms or sprinkler systems, made them susceptible to having fires. If the fire got a good start, it would not take too long for the whole building to be enveloped in flames as the factory got consumed by the fire. This was the situation when the Chase block fire occurred on February 7, 1935, (see images above and below.) It was bitter cold, and the firemen who tried to control the fire were hampered by poor equipment and freezing temperatures. (HHS.)

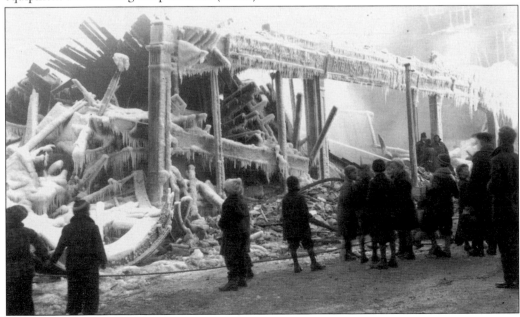

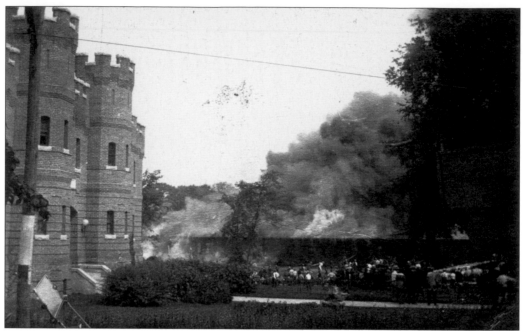

This fire was at the Hudson Counter Company in 1913, which was adjacent to the Hudson Armory. Henry B. Whitcomb was the owner. This was later the site of W. T. Grant Company, then Robinson Hardware, then Ace Hardware. The "counter" is the interior support of a shoe and was supplied by the Hudson Counter Company to the many shoe factories in Hudson and the rest of the United States. (HHS.)

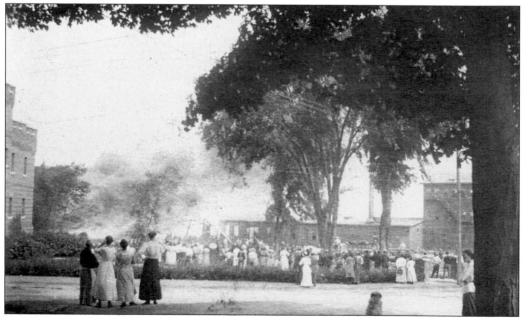

The Hudson Batting Company was in the rear of the Hudson Counter Company on Washington Street and was destroyed in the fire of 1913 along with the Hudson Counter Company. The formally dressed women were probably workers employed at the burning buildings watching their jobs go up in flames. (HHS.)

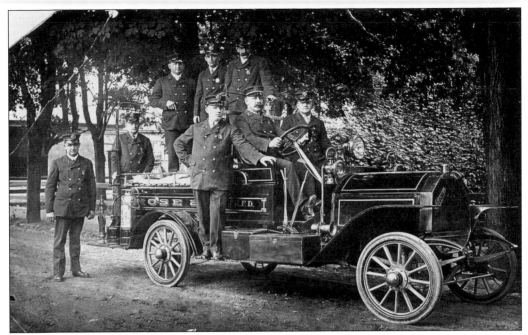

Hudson's first motorized fire apparatus was this 1913 Grout truck purchased for Hose Company 6, No. 2 from the Grout automobile company in Orange, Massachusetts, and replaced a horse–drawn fire wagon. Hose No. 2 was located in a firehouse on High Street. Capt. Fred Murphy is sitting behind the wheel. (HHS.)

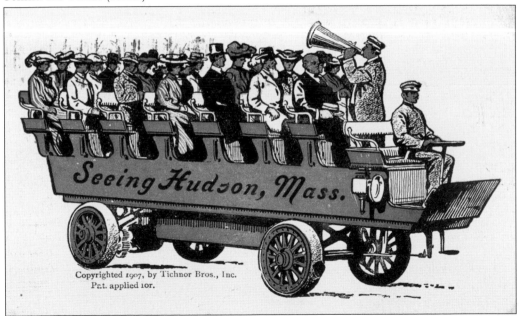

This humorous souvenir postcard, postmarked in 1907, is from a postcard booklet and titled "Seeing Hudson." It was a common postcard sold in almost any town that had frequent tourists, and the printer of the card need only change the name of the town. The wagon, if it ever existed, was an electric battery–operated wagon with no protection for its passengers from any rain or sun. (RO.)

Amateur Radio Station
W1FL

Radio _W1IQR_ gld to QSO _9.00 P.M. EST. 2/11_ 193_6_
Ur sigs were RST _5-4-9_ on _5 R_ Band.
Xmtr: _5 E-58 - into M I aul_
Rcvr: _Tuned RF super-regen -_
Remarks _Glad to gud. Ed + hope to do it often_ Pse QSL

Don Meserve. 140 Forest Ave., Hudson, Mass.

Amateur radio was a popular hobby for many residents of Hudson, almost from the beginning of this hobby. One had to have an amateur radio license issued by the federal government that required taking a test consisting of a written part and a code part. The written part tested the applicant's understanding of the technical aspects of radio transmitters and receivers, and the code part tested the applicant's ability to communicate using Morse code (dots and dashes, similar to telegraphy). Those who passed both tests were issued an amateur radio license that allowed them to transmit and receive radio communications over radio frequencies reserved just for the amateur radio hobbyists. Often these "amateurs" designed and built their own transmitters, receivers, and antennas and were instrumental in advancing wireless radio and later television. (PP.)

Radio _W1IQR_ gld to QSO OM
Ur Sig _R5 S9T_ Condx. _OK_
At _9:30 A_ M EST _3-19-_19_49_
Remarks
TNX FR 40M QSO ED
Tranx _BC 458_ Rcvr _BC 348_
Pwr _50 W._ Ant. _DBLT_
Plse QSL Tnx 73

58A Houghton Street - Hudson, Massachusetts - U. S. A.

W1QQE

EV. HILL - - - OPR.

It was a common procedure for a radio amateur who received a communication from another amateur, especially over a long distance, to mail a postcard to the sender as a verification of the communication, along with other information about how far the transmission went, how strong the signal, what kind of equipment was used, what kind of antenna, and so forth. These postcards were collected as bragging proof of an amateur's activity and how far his equipment was able to reach (often thousands of miles). The amateur's license number, issued by the federal government and giving him permission to use certain radio frequencies for this wireless communication, originally started with the letter *K* but quickly changed to the more common *W*. (PP.)

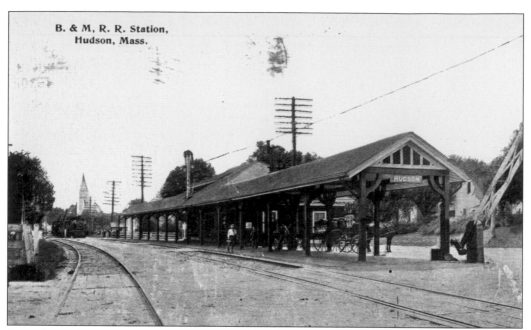

Several people are waiting for the arrival of a train at the Boston and Maine Railroad's Felton Street Station in Hudson. In 1900, as many as 36 trains a day served the town of Hudson on the Boston and Maine Railroad line at two stations in Hudson. St. Michael's Catholic Church can be seen in the background and had at that time only one steeple. (HHS.)

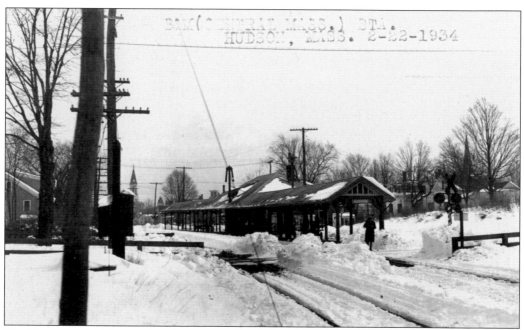

The Boston and Maine Railroad station in Hudson operated in 1934 under a load of snow. Special trains were designed, and their only job was to run down the line and clear large amounts of snow from the tracks. It was still necessary for the stationmaster at each railroad station to shovel the snow around his station so the passengers could get to the trains. (PP.)

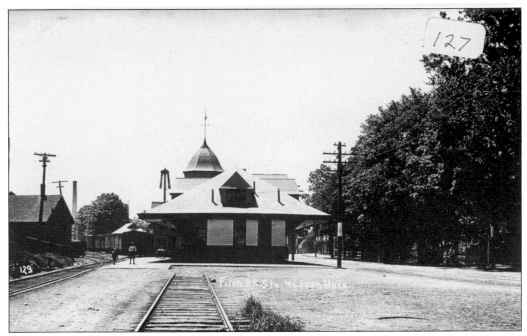

Seen here is the Fitchburg Railroad station in Hudson looking west, viewed from rear of Larkin Lumber. By the side of the station is a signal pole that was used to indicate to the train's engineer if anyone at the station wanted the train to stop. If the signal was not up, the train would not bother stopping, thereby saving a little time. (HHS.)

The Hudson station for the Boston and Maine Central Massachusetts Railroad appears empty, possibly on an early Sunday morning. The long covered open shed on the left of the postcard is the area for both passengers and freight to be loaded or unloaded from a train while it makes a quick stop in Hudson on its way to the next stop on the line. (PP.)

This bridge at the junction in Wilkinsville in Hudson was built in 1881 and was referred to as the "Trestle" over the Fitchburg Railroad line. The picture was taken in 1903. In 1850, the Fitchburg Railroad line was built from South Acton to Feltonville, and in 1853, the line was extended to Marlborough. The fare from Feltonville to Boston was $1.10. (VM.)

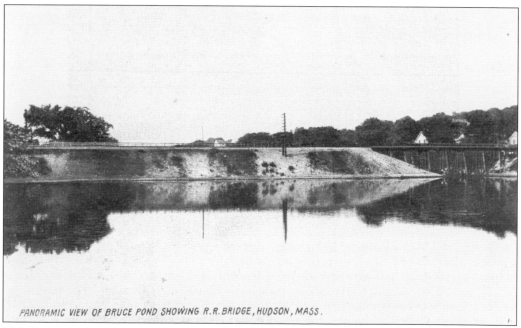

PANORAMIC VIEW OF BRUCE POND SHOWING R.R. BRIDGE, HUDSON, MASS.

This is a panoramic view of Bruce Pond, and it shows the trestle for the Hudson and South Lancaster Railroad that was completed in the late 1800s, running about nine miles from Hudson, across Bruce Pond, into Bolton Center, and ending at South Lancaster. It cost over $220,000 to build but went out of business in 1883 after running just one train over its tracks. (VM.)

B. & M. FOOT BRIDGE, HUDSON, MASS.

The Boston and Maine Railroad had a bridge that crossed scenic Bruce Pond in the northern part of Hudson. In order to keep people off the bridge's tracks, especially kids who used the bridge as a great shortcut to get to school, the railroad made this bridge wide enough to provide for a footbridge attachment to the bridge, complete with handrails for safety. The footbridge became a very popular shortcut by not only the kids but also adults and families as they walked to St. Michael's Catholic Church on Sunday. The church is seen in the background with its two steeples. This view was taken looking east from the Church Street side of the bridge. By 1890, 14 trains daily served Hudson on the Boston and Maine Railroad (Southern Division) and 22 trains daily through the Boston and Maine (Fitchburg Division). The fare to Boston was 60¢ round-trip on the Fitchburg line and 50¢ round-trip on the Southern line. (HHS.)

ACROSS AMERICA, PEOPLE ARE DISCOVERING
SOMETHING WONDERFUL. *THEIR HERITAGE.*

Arcadia Publishing is the leading local history publisher in the United States. With more than 3,000 titles in print and hundreds of new titles released every year, Arcadia has extensive specialized experience chronicling the history of communities and celebrating America's hidden stories, bringing to life the people, places, and events from the past. To discover the history of other communities across the nation, please visit:

www.arcadiapublishing.com

Customized search tools allow you to find regional history books about the town where you grew up, the cities where your friends and family live, the town where your parents met, or even that retirement spot you've been dreaming about.